John Tweed
Sculpting the Empire

John Tweed
Sculpting the Empire

Nicola Capon

Spire Books Ltd

PO Box 2336, Reading RG4 5WJ
in association with
Reading Museum
www.spirebooks.com

This book has been made possible by the generous support of The Paul
Mellon Centre for Studies in British Art

Spire Books Ltd
PO Box 2336, Reading RG4 5WJ
www.spirebooks.com

CIP data: a catalogue record for this book is available from the
British Library
Designed by John Elliott

ISBN 978-1-904965-43-5

Front cover: Tweed with Captain Cook, *c*.1912, clay, in studio
Back cover: *Latona*, *c*.1905, marble

Contents

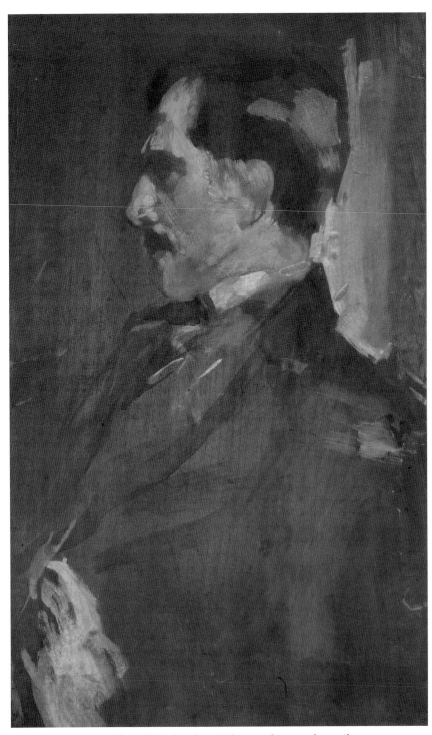

Portrait of Tweed by Edward Arthur Walton, unknown date, oil on canvas.

Preface

John Tweed's career spanned the turn of the twentieth century including the reigns of three monarchs and the First World War. He worked in three great artistic centres – London, Glasgow and Paris – and had close connections to some of the most celebrated artists of his day as well as a large network of patrons in Edwardian society. Heralded as 'the Empire sculptor' during his lifetime, he has been largely neglected by the history of art but his sculptures can still be seen in Africa, Australia, Canada and Yemen.

Born in Glasgow in 1869 Tweed began his career as a student and then teacher at the prestigious Glasgow School of Art. In 1890 he moved to London, found employment working in the studio of Hamo Thornycroft and attended classes at Royal Academy Schools and at Lambeth School of Art. In 1893 he studied at Paris's Ecole des Beaux-Arts for six months.

On returning to London he was offered a commission, through the architect Edwin Lutyens, by Cecil Rhodes for a relief panel for Rhodes' new residence in Cape Town. This was the start of a profitable relationship which led to a significant number of African commissions including three public statues to Cecil Rhodes himself.

At this time Tweed also exhibited at galleries including the Royal Academy, the Glasgow Institute and the International Society. While exhibiting at the latter venue in 1898 he struck up a friendship with the sculptor he most admired, the great Frenchman, Auguste Rodin. His promotion of Rodin in Great Britain was to be a secondary focus for the rest of his career, culminating in the gift to the nation of seventeen works by Rodin in 1914.

Tweed's carefully nurtured society contacts led to many public statues and portrait commissions from British aristocrats and public figures including the writer Charles Whibley and the Archbishop of Canterbury, Cosmo Gordon Lang. In 1903 they also resulted in Tweed being chosen to finish Alfred Stevens' Wellington Monument for St Paul's Cathedral, completed in 1912. During the First World War Tweed was an official war artist for South Africa. The six-month stay with the VI Corps informed his many

post-war memorials for both military organisations and towns across Britain including the National Memorial to Lord Kitchener and the War Memorial for the House of Lords.

Tweed died in 1933 leaving nearly 250 known works and an extensive archive, having had a full and artistically important career. His 1934 memorial retrospective was held appropriately at the Imperial Institute, opened by Princess Alice of Athlone and attended by many of the great and the good of a declining Empire.

Some of the information and all of the illustrations for this book have been drawn from the Tweed Archive belonging to Reading Museum. The archive was given to the Museum in 1963 by the daughters of John Tweed who lived locally. It consists of sculptures, plaster models, correspondence, drawings, sketchbooks, about 650 photographs, press cuttings and miscellaneous personal objects belonging to the sculptor including oil paintings by his friends such as T.C. Roussel and A.E. Walton.

For the past three years, the Arts & Humanities Research Council (AHRC) has provided Nicola Capon with an award as a doctoral student. Supervised by Reading Museum and the University of Reading, she has researched, accessioned, documented and photographed the Tweed Archive for the first time. This has provided accessible storage for the archive, an image database and this publication. The work culminates in 2013 with an exhibition at Reading Museum about Tweed, his work, working practices, networks of patrons, friends and his personal collection.

Elaine Blake
Reading Museum
November 2012

1 John Tweed: an introduction

John Tweed was, during his lifetime, a hugely successful sculptor **(1.1)**. He lived and worked during a period of enormous expansion in the arts where the awareness and the size of the exhibition–going public was growing. The case study of his career exemplifies that of a professional sculptor at the start of the twentieth century. He is now not as well-known as some of his contemporaries and his sculpture has historically not been viewed as either modern or innovative; he has been considered as a 'traditional Victorian' and as an 'academic' sculptor. These labels are misleading; Tweed was not simply reproducing a classical ideal that he had been taught in the Royal Academy Schools. Nor was he derivatively copying style and substance from his self-appointed *maître*, Rodin. He had his own agenda and his own views on what he considered to be good art and what he considered to be beautiful. As with all opinions on art they differ from other views set out in the period during which he lived but this does not deny the validity of either his ideas or of his artistic sensibilities.

The range of sculpture Tweed produced reflects the types of work that were typical employment for practitioners of this period. Portraiture was a major part of many artists' practice and they relied on personal contacts and networks of patrons for commissions. Tweed was the only sculptor to produce a portrait from life of the Cape Colony leader Cecil Rhodes; he produced a number of personal works for Rhodes himself but he created numerous sculptures of Rhodes for African patrons throughout his career. The aristocratic patrons who commissioned Tweed to produce portrait busts would also often recommend him for larger public works. Perhaps most importantly Tweed's friendship with Auguste Rodin and the publicity it brought gave him access to patrons and commissions he may have not otherwise received.

Despite a heavy work load of patron-led commissions Tweed still spent time experimenting with sculpture and the human figure, still searching for his own ideal, his own discoveries within his art. The critic Kineton Parkes

wrote of one of his ideal works, 'Latona is the most important. This naturalistic, crouching figure in marble represents Tweed's art in its most attractive, if not uncompromising, guise.' **(1.2)**.[1] In contrast with commissioned portraits or public statues, ideal statues allowed artists to present more abstract concepts of beauty, form, physicality and surface. They were frequently exhibited at the Royal Academy and a growing number of other art galleries to showcase a sculptor's talent. Ideal works were entirely imaginative and often pushed the boundaries of the sculptor's art. Whereas public statues and portraiture required a sense of likeness and accurate costume details, as well as abstract qualities such as strength, vigour or nobility. Tweed's statue of Captain Cook was praised for its strong portrait of masculinity and for its excellent likeness of an imperial hero.

The late nineteenth century saw a huge rise in the number of large-scale public statues being erected which provided a stable income for sculptors **(1.3)**. These works were commissioned for all over Britain and the Empire; sculptures by Tweed were put up in Africa, India, Australia and Hawaii. They

1.1 Tweed in studio, *c.*1903, London.

1.2 *Latona*, *c.*1905, marble.

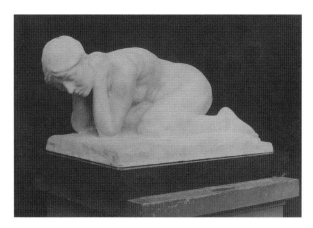

were normally erected outside in public spaces but also included pieces inside public buildings such as churches and government offices. This expansion created work for one of the largest communities of sculptors ever to work in London and Tweed was part of this group.

The success of Tweed's career can be seen in the latter decades of his life. After the First World War he was given numerous large-scale commissions by the government, local councils, regiments and private organisations. These also included the National Memorial to Lord Kitchener and the Peer's War Memorial for the House of Lords **(1.4)**. During the last six months of the war Tweed visited the frontline in France as a war artist employed by the South African general, Jan Smuts; he witnessed the war at first hand and this experience directly influenced his work on memorials.

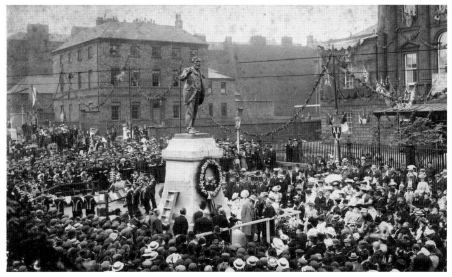

1.3 Unveiling of the statue of Joseph Cowan by Tweed, Hexham, 1905, bronze and stone.

John Tweed: an introduction

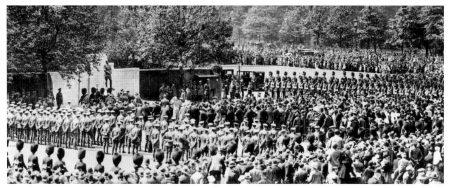

1.4 Unveiling of the National Memorial to Lord Kitchener, London, 1926, bronze and stone.

Tweed's career should be considered, along with many of his colleagues, as a constant process of negotiation both between his own style and that of other artists, patron's expectations and an art world that expected inspiring public monuments alongside complicated and innovative ideal sculpture. His pupil Clare Sheridan described her teacher as, 'a temperamental genius, oppressed like most artists by the necessity of money, and obliged therefore to accept orders that were almost suicidally distasteful to him'.[2] Tweed was neither a modern artist striving against a homogenous academic art world, nor an academic, conservative sculptor himself. He was a professional artist working in one of the most competitive art societies of the last century. Despite being nominated to the Royal Academy in London fourteen times, Tweed was never granted his associateship; he was unable to fit in the traditional home of British art and dismissed as unfashionable by the champions of modernity.

Reconciling Tweed with the canon of modern British sculpture is not a simple process of inserting him into this group of artists. His work needs to be reappraised and his individual attitudes to his medium and to his art need to be validated allowing for a more complex picture of sculpture to emerge. This catalogue seeks to do that by studying, for the first time, the collection of documents in the Tweed Archive. It reveals a man who earned a reputation as a professional sculptor capable of producing objects that had both artistic merit and that met his patron's requirements for representation of both likenesses and of abstract concepts that many felt public sculpture had to embody. It shows the importance he had in introducing the works of other renowned artists to the British public. Ultimately it reveals an artist who produced a breadth of works but also was deeply involved in European art society during an exciting period in the early twentieth century.

2 The beginnings of a career

Glasgow

John Tweed, the eldest of four children, was born in January 1869 in Glasgow to the publisher John Tweed senior and his second wife Elizabeth Montgomerie. His childhood home stood near the south banks of the Clyde and was a modest but prosperous affair. Tweed attended the local grammar school until 1882 when at the age of thirteen he began taking classes at the Glasgow School of Art (GSA).

The formation of government-funded schools of art and design was inspired directly by the Great Exhibition in 1851. In the years preceding the exhibition there had been a government investigation into the state of art and design education in Britain, because British art education was felt to lag behind the rest of Europe. The Great Exhibition was the culmination of this investigation and served as an advertisement to the rest of Europe of Britain's growing skills. The GSA, like many other government art schools, grew out of an existing private school. For Tweed and other artists of his generation joining a government art school was a relatively new way to train. The establishment of such schools was intended to open up art education to craftsmen and artisans and to produce a more standardised artistic education across the country, at arm's length from London and independent from the monopoly of the Royal Academy Schools.

It is unclear when Tweed decided to become an artist but it must have been at a young age. His daughter, Lendal, described her father as having early ambitions: 'in his boyhood he showed a predilection for drawing, and began modelling with the only material that lay to his hand, which was dough.'[1] The archives of the GSA show that Tweed started classes in 1882 as an apprentice litho-draughtsman. This is likely to have been connected to his father's business and may have been a way for John Tweed senior to allow his son to follow his dreams of becoming an artist while still being involved in publishing. His father's publishing company would have used lithography

to illustrate their books. In 1883 Tweed was listed as an apprentice and he undertook and passed a local examination in free-hand drawing.

However, in 1884 Tweed was listed as a modeller and in 1885, he became an apprentice sculptor. His father died in the latter year and this seems to have freed Tweed to pursue his artistic dreams, even though the situation made him, at sixteen, the person responsible for his mother and three younger siblings. Lendal Tweed felt that this was a very difficult burden and as such Tweed was unhappy with his life during his late teens and early twenties. In a letter written to Hamo Thornycroft in 1888 he discussed the problems it caused for his art career:

> I may say that I am the oldest of my family, and since my father's death, have had to manage his business for my mother. If my father had lived I should have had the means to have studied in London. I will still continue to model and draw as much as possible, and through time circumstances may alter, and I yet may succeed .[2]

Tweed's classes at the GSA continued. In 1886 he had enrolled as an apprentice sculptor and as a carver; he was branching out into a specific discipline. The diary he began to keep in 1887 shows that he attended classes both during the day and in the evening. The student registers for 1887 have been lost but Tweed achieved a third grade prize in a 'National Competition for Modelling a Figure from Cast' and passed a local examination in advanced modelling. His diary entry for 17 February 1888 is a typically brusque comment, 'At Modelling Exam was able to do the model I got.'[2]

When Tweed began taking modelling classes in 1884, these were run by a Mr Francis Leslie (1833-94) with the help of the visiting sculpture master, John Mossman (1817-90), who was one of the most prominent sculptors in west Scotland during the late nineteenth century. With the advent of Francis Henry Newbery's (1855-1946) period as headmaster guest artists were also invited to visit the school and run practical demonstrations. Tweed was present at one such guest demonstration; in his diaries he remarked every day for a week on the classes he attended given by the French sculptor Edouard Lanteri (1848-1917) then the Professor of Modelling at the South Kensington School of Art. On 12 March he also proudly recorded that he had shown photographs of his most recent project of a bust of an old man to Lanteri: 'I showed my photo to M. Lanteri, he considered it very clever, and he advised me to look after my anatomy and breadth.'[3]

Late in 1888 Tweed was given the offer to join the teaching staff, in recognition of his talent, as he was obviously considered adept enough to be able to teach other students. In the April of 1888 the modelling master

Francis Leslie resigned and the gap had been filled by other members of staff especially the design master, Aston Nicholas. The governors' minutes from 6 December 1888 explained that:

> he [the headmaster] had succeeded in securing Mr. Kellock Brown to come say once a week to give lessons in Modelling for a few weeks … and he had engaged Mr. John Tweed at a small salary to be afterwards fixed to attend the day modelling class. These engagements were considered desirable and authorised.[4]

On 12 November 1888 Tweed reported in his diary that he had 'commenced teaching modelling in the School of Art'. He continued to mention his classes over the next few days, keeping note as the number of pupils rose to eight and then to eleven.[5]

Tweed's time at the GSA was incredibly important to his development as an artist. The school taught him to draw and how to draw from the human figure; it taught him anatomy, modelling, carving, casting, and many other skills which he continued to use throughout his career. The GSA is now rightly considered to have been one of the best art schools in the country and one of the most innovative. Tweed attended the school at the same time as Charles Rennie Mackintosh and although he had left by the time Mackintosh and his Glasgow style made the school famous, the influence of the school's celebrity did not hinder his career. Tweed trained in three different countries at five different institutions or studios. He spent the longest period at Glasgow and it can be argued learnt the most there.

Building a profession

During the late 1880s while still teaching at the GSA, Tweed took a studio at 18 Willowbank Street, Glasgow. The street still exists with its Georgian terraced town houses, the large bay windows providing excellent light for the rooms inside. On 5 December 1888 he wrote in his diary, 'Got into my studio today. Working in it in my dinner hour.'[6]

Tweed's first professional work was a relief portrait of the philosopher Thomas Carlyle, which he began with the encouragement of A.J. Symington. Symington was an acquaintance Tweed met through his publishing work but he was also a collector of Thomas Carlyle memorabilia and allowed the young artist to study his collection in preparation for the relief which Tweed sold to the bookseller Allan Park Paton (**2.1**).[7] At around the same time Tweed began to give private modelling lessons to a young woman, the daughter of G.V. Isaacs.[8]

In the 1880s Tweed assisted other sculptors in Glasgow. He worked with

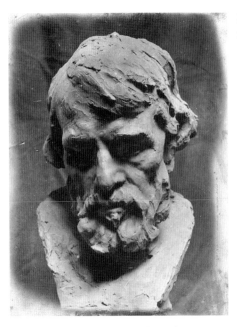

2.1 Bust of Thomas Carlyle, *c*.1889, clay in studio.

George A. Lawson on the Glasgow Municipal Buildings in George Square, carving parts of the Jubilee pediment, which was finished just in time for Queen Victoria's Jubilee visit of 1887.[9] Tweed was invited, as an artist who had worked on the decoration, to witness the Queen opening the buildings **(2.2)**.[10]

Tweed was also trying to expand his practice by writing to various proponents of the art world in order to promote his career. One recipient was Sir Walter Armstrong to whom he sent photographs of his work. A letter from Armstrong dated July 1889 reads:

> So far as I can judge from the photographs you have sent me, you have that first necessity for success in art, a real sympathy with the material in which you have elected to work and something to say which that material, and no other can say to perfection.[11]

Sir Walter Armstrong was a well-known art historian and critic and in 1889 the director of the National Gallery of Ireland. He was supportive of Tweed's efforts to make it in the art world and over the next year met him several times in Glasgow to advise him on his career.[12] In February 1890 he wrote:

> I have spoken of you to Hamo Thorneycroft [sic], to Onslow Ford, to Alfred Gilbert, and to one or two others, but they none of them have anything on hand at the moment on which you can give assistance ...
> I think you ought to do some small thing for the academy, the bust of

some strongly marked old woman or man, for choice, so that there might be something here to back one's words if one got a chance of an opening for you.[13]

Independent of Armstrong's approach, Tweed also corresponded with the sculptor Hamo Thornycroft (1850-1925). He was an established and successful London sculptor who, during the 1880s, was working at the forefront of the New Sculpture movement; a group of sculptors who focused on ideal imaginative sculpture as well as portraiture and public sculpture. Thornycroft sent Tweed a letter in 1888 with advice for the young sculptor:

anyone not having private means and taking up sculpture as a profession will have a hard and uncertain means of livelihood, and I never would recommend it unless the student has distinct talent … At present I have no work which I could employ you – but if you are in London at anytime I shall be pleased to see you.[14]

In 1890 an acquaintance, Captain Strong, arranged for Tweed to enter a competition to produce a monument to the Earl of Angus for the Cameronian Regiment.[15] On finding later that summer that he had lost out to Thomas Brock, a sculptor from London and an associate of the Royal

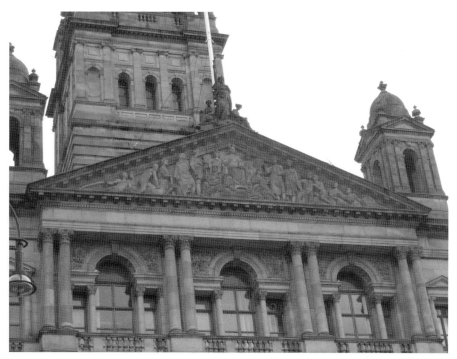

2.2 Jubilee Pediment, Glasgow Municipal Building, James Ewing and Company, *c.*1887, stone.

Academy, Tweed seems to have felt that there was only one way to move his career forward – he must go to London. Tweed sold his father's business, the profits of which were given to his family. He then applied for and successfully gained a teaching position at the School of Art at the Crystal Palace which he hoped would support him while he was living in London.[16] The last entry in the old exercise book Tweed used for a diary reads as follows:

> 13th September 1890 – Left Glasgow today at 12:45pm. I felt very sorry at leaving them all, I kept up but it was very hard. It seemed as if my life were just commencing. I would either be successful or a failure. Such thoughts came crowding into my mind that I felt unable to talk or read.[17]

London

On arriving in London in the autumn of 1890 Tweed found that the teaching job he had been relying on had fallen through. Staying with friends of a Glasgow patron, Lady Henrietta Grant, he began to visit the major sculpture studios of London. Taking up Hamo Thornycroft's earlier invitation Tweed visited his studio. Thornycroft had just agreed to produce the frieze for his friend Thomas Belcher's Institute of Chartered Accountants (ICA) and had need of a sculptural assistant. Along with C.J. Allen, Tweed became part of Thornycroft's busy Kensington studio. Hamo Thornycroft came from a family of sculptors; both his mother Mary and father Thomas had produced public statues in London during the middle of the nineteenth century.

In his youth Thornycroft trained under Frederic Leighton at the Royal Academy Schools,[18] and, by the late 1880s, was well-known and successful. He had recently finished the statue of General Gordon for London as well as a bust of the architect John Belcher and a marble bust of Elizabeth Gaskell for Manchester Library.[19] As well as running a busy studio Thornycroft was an active member of the Royal Academy and the Art Workers' Guild. He taught at the Royal Academy Schools and was part of the hanging committee for the summer exhibition.[20] As Elfrida Manning, Thornycroft's daughter and biographer noted, Tweed arrived at Thornycroft's Kensington studio just at a time when he needed more help to deal with an influx of large scale works:

> With so much work in hand, Hamo took on a couple of pupil assistants. In 1890 C.J. Allen and John Tweed came to work for him. Allen, with the pointer, Smith, began work on *John Bright*, later he and Tweed were set to work on the Trinity Church apostles, each with a model. In 1892 they joined George Hardie on the carving of the Chartered Accountants frieze.[21]

The ICA was Thornycroft's biggest project to date, its architectural

nature making it particularly unusual. Both Thornycroft and the architect Belcher were founding members of the Art Workers' Guild, a society formed to promote unity in the arts, as such their interest in sharing the artistic consideration of a major London building was indebted to these ideas of collaboration. The frieze was to be a series of panels that ran around the middle storeys of the building in two registers, depicting in relief industries that the accountants worked for. It was an illustration of the building's inhabitants and an advertisement of their work which the panels showed helped to run the country and the Empire.

Each panel took a similar form but with individual details to illustrate thirteen of the industries that the ICA worked with. For example, the panel 'Railways' upon which Tweed worked depicts five figures; in the centre an allegorical representation of the industry as a classically draped woman in this instance shown with wings to denote the speed of modern transport. She is flanked by two women in contemporary dress who were to illustrate the passengers that travel by railway, while two men on the opposite side represent the freight industry and the railway's importance to the Post Office. The ICA was the biggest building project in the City at the time and was certainly a prestigious and useful experience for Tweed so early in his career.

Tweed's work on the ICA included making the clay models for the panels depicting 'Railways' and 'Commerce', Thornycroft's diaries for 1891 show that he worked on these panels throughout the autumn and winter. Susan Beattie in her discussion of the ICA asserts that Tweed and Allen would have helped to carve the panels *in situ*; plaster casts were taken of the clay models and then hoisted up to sit alongside the stone so carvers could follow the models directly.[22]

Tweed carried out other work for Thornycroft such as the figures of the apostles for Holy Trinity Church in Sloane Square by J.D. Sedding (1838-91) which was a product of the Art Workers' Guild ideas of the marriage of arts to produce beautiful spaces. It remains today one of the best examples of the Arts and Crafts movement. At the back of a journal for 1891, Thornycroft wrote on the accounts page for 2 November, 'Tweed came to work first time he set up S. Peter, Orazio [a model] sat to him.'[23]

Allen and Tweed were both given models to work with from the start; they were given a certain amount of freedom and both of them were considered able enough to work straight on the human figure. Sculpture students were often limited to working from plaster casts and on ornamental patterns before being allowed to work from live models. Interestingly, Orazio refers to Orazio Cervi, an Italian who would have modelled annually for Thornycroft.[24] A list of artworks annotated by Tweed in the Tweed Archive

includes an ideal work as being called *Cervi* (now lost), proof perhaps that he was using Thornycroft's models to work on his own ideas.

Later, in 1901 Tweed was commissioned to produce a marble reredos screen for the Holy Trinity Church. The original plan was to have this piece of work produced by Harry Bates, who had already made the altar front in marble relief, but after Bates' death in 1900 the work was left incomplete. Tweed's marble reredos depicts Christ on the Cross surrounded by the Virgin and disciples while two side panels show St John the Baptist and the Virgin and Child.

Thornycroft allowed his assistants other training and opportunities; one of the conditions of Tweed's position in Thornycroft's studio was that he was to enter the RA Schools. In order to gain a place students had to submit a piece of work that illustrated their skill; on his first attempt in 1890 Tweed failed to impress the judges. For the next year he attended classes at the Lambeth School of Art one day a week. He then tried again and stubbornly used the same work that had been rejected the year before; this time it was accepted and in 1891 he began to take classes at the RA possibly taught by Alphonse Legros and Francis Derwent Wood. That year Thornycroft also sent Tweed and Allen to Paris for a short trip[25] so that they could study art on the continent; this trip seems to have made up Tweed's mind to study in Paris as well as in London.

Thornycroft's studio would have been a hub for many influential artists, patrons and dealers. Tweed's introduction to the art dealer and statuette publisher Arthur Collie seems to have come through Thornycroft's studio when Collie was producing Thornycroft's statue of General Gordon as a small statuette to be exhibited at the RA. Collie later became a valuable contact for Tweed and was responsible for helping him to gain commissions from Cecil Rhodes.

At the studio Tweed met many models who Thornycroft were employed for his various works, including other members of the Thornycroft family.[26] Like Frederic, Lord Leighton and several late Victorian painters, including John Everett Millais and Lawrence Alma-Tadema, Thornycroft was very fond of working with the Pettigrew sisters; Lily, Hetty and Rose. The sisters were Pre-Raphaelite 'stunners' with long red hair and large rosebud lips. Lily and Hetty both modelled for figures on the ICA frieze and during this time Hetty seems to have started a close relationship with Tweed. Her sister Rose's memoir, recalls her time as a model and mentions that they posed for many artists including, 'John Tweed to whom my sister Hetty became engaged'.[27] Lendal Tweed does not mention this and we have no exact dates for their relationship or how it progressed. We know that Tweed had met his

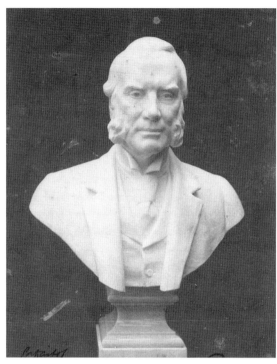

2.3 Bust of C.S. Parker,
c.1891–3, marble.

future wife, Edith Clinton, by the time he left Thornycroft's studio for Paris in mid-1893. Hetty continued to work as an artist's model and became the favourite model and lover of Tweed's close friend Théodore Roussel. She is the model in Roussel's most famous painting *Reading Girl* (1886-7) which Tweed fought to have placed in the Tate after Roussel's death in 1926.

By 1892 Tweed had found himself a room of his own in Chelsea, which he also used as a small studio. A friend from this period, the young actor Sidney Blow, described the room in his memoirs giving a detailed description of the precarious nature of Tweed's existence in London:

> It was in the ten shilling room that was so economically planned. It was just one room but it had a kitchen and wash place – that bit in the corner behind the red velvet curtain that sagged so on a limp string. Then there was the bedroom – that was where the iron bed stood. The sitting room was in the window where the occasional table got in your way when you wanted to look out of the window and see if it was raining. And the studio – that was all the rest of the room between the door and the bedroom. An R. White's Ginger Beer box was the rostrum. A high-legged flower-stand that once had palms on it in a Pimlico best room but had found its way to the junk shop in Church Street was his modelling stand; a box with 'Please return to Whitley's' printed in large letters contained the clay and the floor was laid with a piece of worn-out linoleum.[28]

Tweed used this space to work on his own sculpture, including small portrait commissions and his small ideal works. Blow also remembered meeting Hetty Pettigrew in this room, modelling in the nude for free as Tweed could not afford to hire models. It was during this period that Tweed gained his first professional commission, a bust of the Scottish politician C.S. Parker. Mrs Hill, a fellow student from the GSA, seems to have been instrumental in getting him the job. The commission turned out to be a steep learning curve for Tweed who enjoyed the sittings with Dr Parker and produced a bust that the sitter found agreeable. However, on presenting the bust to the commissioning committee he was forced to spend another year making changes specified by the committee before the bust was grudgingly accepted **(2.3)**. The difficulty of the Parker portrait seems to have been one of the reasons that persuaded Tweed to give up his position in Thornycroft's studio and venture to Paris. So in the September of 1893, waved off from Liverpool Street by his new fiancée Edith, Tweed left for France.

3 Rodin

Paris: 1893

The six months that Tweed spent in Paris from September 1893 until the following spring became, in his eyes, the turning point of his career. Later in life he would often reminisce of his time in the French capital; friends would be surprised that he had only stayed for six months since his stories gave the impression he had been a native for years.[1] Paris, in 1893, was still the European, if not the world capital, of art. The controversy of Impressionism had begun to recede and artists such as Van Gogh, Gauguin and Cezanne were beginning to shock Parisian audiences. In sculpture, Paris was dominated by France's two most famous sculptors Alexandre Falguière (1831-1900) and Auguste Rodin (1840-1917). Tweed was to be taught by both.

Falguière was the more conservative of the two, running the largest studio in Paris as well as teaching sculpture at the Ecole des Beaux-Arts, the French equivalent of the Royal Academy. Rodin, in the early 1890s, was both celebrated and despised in almost equal measure. He had been recently employed upon the large public commissions of memorials to the writers Victor Hugo and Honoré Balzac, both works were hugely controversial for their unorthodox interpretation of the form of the public statue and for Rodin's rugged and textured use of surface.

Tweed had been enamoured of Rodin's sculpture since his days at the GSA. Sir Walter Armstrong had often sent him prints of modern sculpture which had included Rodin's works. His decision to move to Paris was made with the hope that he would find a way to be taught by the great man. Lendal Tweed noted that Tweed approached Rodin upon his arrival in Paris and that Rodin was willing to take him on as a pupil but only on the basis that he became an apprentice for four years. This was not a commitment that Tweed could agree to; he was still nominally responsible for his family in Glasgow and had left his fiancée in London. He was also by now a professional sculptor, who in London had held a position in a respected

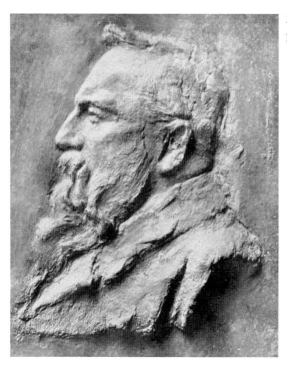

3.1 Portrait of Rodin, *c.*1904, plaster.

studio. To become a student again, for another four years, would have been a difficult step back down the career ladder, despite the attractions of Rodin's obvious innovation and skill. In the end Tweed studied under Falguière at the Ecole des Beaux-Arts. He may have attended some of Rodin's famous open Saturdays at his Rue de l'Universitié studio but there is no evidence that he had any further contact with his favourite sculptor until 1898.

Auguste Rodin was born in 1851 and was self-taught as a sculptor; working for nearly twenty years before achieving recognition in 1889 with the exhibition of *L'age d'airain* in Brussels. He preferred his own students to follow an apprenticeship rather than studying at the various art schools, as he disagreed with the practice of making beginners learn to draw from plaster casts and extolled to his students the value of studying nature from the start.[2] By the 1890s Rodin's fame was rising and by 1900 he was probably the most famous sculptor in Europe. He is seen today as the father of modern sculpture and a pivotal force in the creation of modern art. Rodin's celebrity opened doors for Tweed within the artistic circles of British society but his connection to Rodin may have overshadowed his own sculptural career **(3.1)**.

We know very little of the rest of Tweed's time in Paris in 1893, as he had given up keeping his journal on arriving in London three years

previously. He was still trying to compromise on the finished bust of C.S. Parker and he wrote to Thornycroft from Paris asking him to write to the committee on his behalf but did not reveal his activities in Paris. However, the brief connection between Tweed and Rodin in 1893 was the start of a relationship that was to be profitable to both men and which shaped the reception of sculpture in Britain at the turn of the century. In the early 1900s Tweed and his young family visited Rodin at his house outside of Paris many times; long enough for the outbuilding in which Tweed worked with Rodin to become affectionately known as the Atelier Tweed. As well as helping Rodin with his affairs in Britain, including the erection of the London *Les Bourgeois des Calais (The Burghers of Calais)* and his presidency of the International Society, he also played a central role in two episodes that profoundly changed Rodin's reception in Britain and influenced how we view Rodin in Britain today. Both concern the gift of sculpture by Rodin to the Victoria and Albert Museum and they document the beginning and the end of Tweed and Rodin's relationship while also giving a sense of his importance in promoting Rodin in Britain **(3.2)**.

Saint Jean Baptiste

When Tweed returned to London in 1894 he continued to live in his small room in Chelsea but also hired a small studio off Regent Street. His career began to pick up and he was increasingly scrutinised by the artistic circles in London. In 1898 he was subject to his first magazine article in *The Idler* written by Roy Compton; in the same year he exhibited for the first time

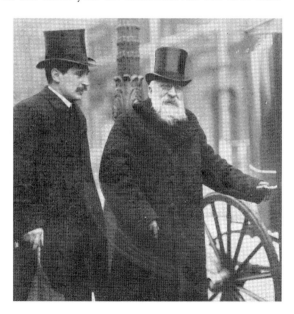

3.2 Tweed and Rodin, 1903, newspaper cutting.

25

with the International Society of Sculptors, Painters and Gravers alongside Rodin and it seems that it was at this exhibition that their friendship truly began. Not long afterwards Tweed sent his first letter to his 'Dear Master'.[3] The letter contained his opinion on the admirable qualities of Rodin's style and skills. It also mentioned that Edith Tweed (the couple married in 1895) was compiling an article on Rodin for the monthly magazine *The Artist* and Tweed asked for photographs that Rodin would like to be included. The article does not appear to have been published but it was the first occasion that he attempted to publicise his admiration of Rodin's art.

A few years later Tweed was truly able to bring Rodin to a wider British audience; in 1900 he responded to a supportive article on Rodin by the painter and critic D.S. MacColl in the *Saturday Review*. Tweed condemned the lack of work by Rodin in London museums and suggested an appeal to raise money by subscription to purchase an important Rodin bronze for the nation. His idea was backed by the *Saturday Review* and by MacColl who, along with Tweed, formed a committee to collect donations for the project.

Other members of the committee included the painters John Singer-Sargent and William Rothenstein, and the sculptors Alfred Gilbert and Thomas Brock. All were men with an admiration of Rodin and a connection to Tweed. Sargent had a studio close to Tweed's Chelsea flat while Rothenstein

3.3 Letter from Auguste Rodin to Tweed, 1901.

3.4 Café Royal dinner guest
list in Tweed's hand, 1902.

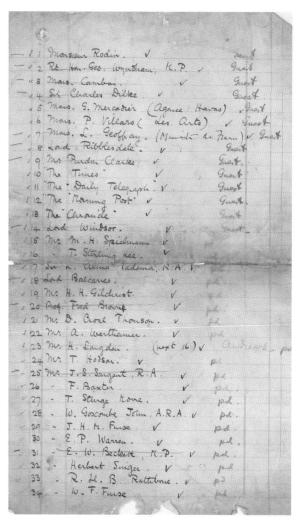

was already working with Rodin through the Carfax Gallery. Gilbert had
met Tweed in the early 1890s when he had been looking for work. Much
later in the 1920s Tweed would be pivotal in repatronising Gilbert into
British society after debt forced him into self-imposed exile in Europe

The appeal was widely covered in the press and another letter appeared
discussing the purchase of a Rodin sculpture in the following issue of the
Review. The MP and banker Ernest Beckett[4] offered to pay for the sculpture
in its entirety. The committee immediately planned a counter-offer asking
Ernest Beckett to purchase a second Rodin work as subscriptions were
already pouring in to pay for the first. In the end this was a wise choice as
Beckett, despite spending years being involved with the project and Rodin
himself, never actually purchased a second work **(3.3)**.

The committee used the money from the public subscriptions to purchase a bronze of Rodin's *Saint Jean Baptiste*. The Victoria & Albert Museum was given first refusal and accepted the work. An unveiling ceremony and dinner in Rodin's honour was planned for May 1902 but almost failed to happen since, persuaded to visit the opening of an exhibition in Prague, Rodin nearly cancelled his trip to London. A hasty letter written by Tweed imploring him to keep his commitment to the project convinced Rodin to visit London, his first since 1878 **(3.4)**.[5]

The dinner, held at the Café Royal on the evening of 2 May, became the moment that cemented Rodin's reputation in Britain. Presided over by the MP George Wyndham it was attended by the cream of London's artistic society. Press coverage was widespread after the evening ended with students from the Slade Art School unhorsing Rodin's carriage and pulling it themselves through the streets of London to the nearby Athenaeum where the celebrations continued. The success of the purchase of *Saint Jean Baptiste* not only widened Rodin's appeal in Britain but showed Tweed to be an important player in the London art world **(3.5)**.

During the 1902 celebrations Rodin stayed with the Tweeds at their home at 108 Cheyne Walk, a larger house that was only a stone's throw from his original room in Cheyne Row, which he had purchased after his marriage. Tweed became Rodin's confidante and his unofficial agent in Britain; the painter and illustrator Charles Ricketts called him Rodin's 'dreadful bear keeper' for the proprietorial hold he kept on the Frenchman's affairs in Britain.[6] In 1903 when the painter and President of the International Society James McNeill Whistler died, Tweed lobbied successfully for Rodin to become the next President.[7] From 1900 until Rodin's death in 1917 Tweed was to help organise exhibitions, purchases of work, sittings for portraits and commissions for English patrons.

Tweed's work for Rodin in Britain can be seen in the correspondence between the two artists. In 1905 when Eve Fairfax, an English aristocrat who had sat for several busts, wrote to Rodin asking him to visit her in York, she also invited Tweed to accompany the Frenchman. Rodin wrote to him in 1905, 'I have also had the good news that towards the 1st September you will be coming to Scotland with me. Mademoiselle Fairfax has written to tell me so.'[8] In a letter from Rodin written in August he mentions the trip again: 'I must be disturbing you very much! Although Mademoiselle Fairfax has engaged you to go with me I am always worried about your time'.[9] He continued, 'Also my friend I definitely do not want to disturb you and I ask a thousand things – you know me. P.S. If you would be so good as to warn the Duchess of Bedford for the 27th she lives near to London I believe'.[10]

3.5 Rodin dinner at the
Café Royal, 1902.

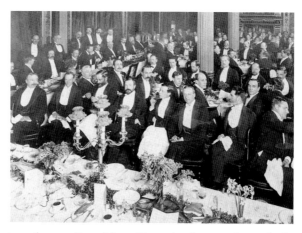

Despite Rodin's worries about disturbing Tweed, almost the whole of their correspondence from the late 1890s until Rodin's death in 1917 is peppered with similar requests for him to contact various members of British society with whom Rodin had business. This was almost certainly connected to Rodin's inability to speak English. He became far more comfortable in relaying messages to Tweed or his wife in French so that they could translate them into the appropriate form to be delivered to the intended recipients. Rodin relied on Tweed when he was in England as a translator at many of the functions to which he was invited. This also applied to the letters when Rodin was writing from Paris. Often Tweed's role would stop after translating a letter of introduction because nearly all of Rodin's correspondents in Britain were upper class and as such would have learned French at school. Once Rodin was aware that he could converse with the recipient in his mother tongue Tweed's involvement was unnecessary.

Tweed did not suffer from the extra workload. In fact he gained a huge amount from his connection to Rodin and the popular press would, whenever they wrote about Tweed, mention the fact that he was a friend and pupil of the great French sculptor. After the 1902 Café Royal dinner the *Morning Post* said that Tweed's statue of Cecil Rhodes 'has gained the commendation of an artist no less distinguished than M. Rodin'.[11] In addition, three of Rodin's English sitters also commissioned works from Tweed. George Wyndham sat for a portrait bust, although it is uncertain as to whether this work was completed, and Lord Howard de Walden commissioned him to produce a memorial to his mother for his estate in Northumberland. In 1903 after the death of W.E. Henley, an important promoter of Rodin, he received a commission to produce a memorial to Henley for St Paul's Cathedral; Rodin gave Tweed the commission of producing the marble pedestal and surround.

The gift to the nation

Towards the end of Rodin's life Tweed played a central role in an extremely significant project for Britain, the gift of a collection of Rodin's work to the Victoria and Albert Museum (V&A). In July 1914 Rodin contributed nineteen works to the London exhibition *L'art Français decoratif contemporain 1800-1885* held in Grosvenor House which was owned by the Duke of Westminster. Rodin was the only sculptor exhibiting amongst painters and other decorative artists. The collection he sent was designed to be representative of his career including portraiture (*Bust of Eve Fairfax* and *Bust of the Duchess of Choiseul*), ideal works (*Cupid and Psyche, The Fallen Angel*) as well as larger works including *The Age of Bronze* and a *Study for Balzac*.[12] Rodin also included his portrait of George Wyndham, who had died the year before, and who happened to be through Wyndham's marriage to Sibell Grosvenor, the Duke of Westminster's step-father. Rodin wrote to Tweed on 24 June 1914 to tell him:

> I am having an exhibition at the Duke of Westminster's which is to open on the 1st of July. I would be very glad if you would help me by having a look at it as I cannot be there. I would be glad if you would give any advice if it is necessary.[13]

By the summer of 1914 Britain and France nervously anticipated war and at the beginning of August 1914 Rodin was told his works could not be repatriated to France. Panicked, Rodin wrote to Tweed on 17th August 1914 to implore him to help look after the works:

> My dear friend, I need your help to find out about the boxes which contain my bronzes that were at the Duke of Westminster's. I cannot find out exactly where they are. Mademoiselle Gregsby of 80 Brook Street is perhaps not in London. I have been told that she has been looking after them up till now but I have no confirmation of this as I have had no letter from her ... They tell me that my boxes are at the packers ... but dear friend this is not what Mademoiselle O'Connor and Madame Greisselle promised me. I would have wanted my boxes to remain in the studios at your house or in studios near to you, this would be better for security. My dear friend could you help me in this matter.[14]

By 23 August, Tweed had resolved the situation and Rodin wrote again to ask his friend to try to organise a different plan for their storage as he was unhappy with the location: 'I do not like these stores; I must admit I would have been very happy if these boxes were to remain either with you or at least a part of them both with Sargent and with Madame Hunter until I could call them back'.[15] Tweed suggested that the V&A could be approached to store the works in the form of a loan exhibition and Rodin replied, 'I

think one could propose for the deposition at Kensington for I could give the Museum several works afterwards'.[16] In the archive of the V&A there is a letter from the Curator of Sculpture, Eric Maclagen, to Sir Cecil Smith, the Director of the Museum, detailing Tweed's plans. It is a testament to the speed at which events unfolded:

> I heard from Tweed yesterday and today went to his studio with reference to the sculpture that was exhibited at Grosvenor House. It has been impossible, owing to the war, to have this sculpture sent back to Paris and Tweed and Rodin himself are anxious that if possible it should be exhibited on loan here. I have seen Rodin's letters to Tweed and Rodin spontaneously suggested that he would like to present a statue to South Kensington later on.[17]

Sir Cecil Smith, despite not sharing "the common admiration of Rodin's work'[18], realised that Rodin would be remembered as a master of modern sculpture and that such a high profile exhibition would raise the museum's profile. As art historian Claudine Mitchell has explained the housing of the loan collection came to be seen as a symbol of the Entente Cordiale and, with the war upon them, emphasised the sense of fraternity that existed between Britain and France.[19] The loan fitted with Rodin's perceived role in Britain. In 1902, at the banquet for the *Saint Jean Baptiste*, he had been called an ambassador of the arts and applauded for using art to strengthen the relationship between the two countries. The war also made the situation unique and as Mitchell has noted:

> The audience of the Grosvenor House exhibition had been confined to the circles of the wealthy, government officials and the aristocracy – to the 'half-crown' visitor, as Maclagen ironically phrased it. If the V&A were to exhibit a leading contemporary French artist, it would be hosting a cultural event sure to be regarded as 'popular' in the circumstances.[20]

On 14 September 1914 Rodin signed the loan form for the V&A and Tweed was entrusted to help arrange the positioning of the sculpture.[21] On 21st Rodin chose Tweed's house to announce that he was intending to offer the entire collection to the V&A Museum. Joy Newton, who has written extensively on Rodin's relationships in Britain, sees this as Rodin showing gratitude for Tweed's friendship and support:

> it was at Tweed's home that Rodin announced his decision to donate the whole collection to Great Britain. With this magnanimous gesture Rodin was paying a public debt of gratitude to a country which had given his work the warmest response he had ever witnessed – but he was also paying a private debt of gratitude to the fellow sculptor who had shown him such abiding filial affection.[22]

The letter Rodin sent to Sir Cecil Smith detailing his idea shows that he came to the decision because 'l'arrangement et la proportion de l'exposition sont parfaits' (the arrangement and proportions of the exhibition are perfect).[23] As an afterthought Rodin added a note to the letter asking that, "les sculpteurs ne serent pas changes se places' (the sculptures will not change places).[24] This particular issue became problematic towards the end of the sculptor's life as he wished the 'Rodin Room' to remain as it had been when the works were first laid out. Claudine Mitchell feels that Rodin's gift to the V&A is part of his ambition to form a Rodin Museum. At the time of the V&A exhibition he was still petitioning the French government to give him the Hôtel Biron to create the Museé Rodin and Mitchell comments that, 'he wished for a Rodin Room at a major London museum'.[25] However, despite this ambition, before 1914, Rodin had not put much thought as to how to achieve this goal. Tweed's suggestion that the V&A house the works from the Grosvenor exhibition temporarily led to the V&A having the world renowned collection that it owns today (3.6).

As Rodin's celebrity grew and his reputation acknowledged by British society, Tweed was recognised alongside Rodin. Tweed may have been overshadowed by Rodin's reflected glory, a fact which may explain why

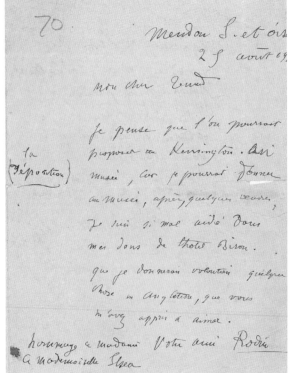

3.6 Letter from Auguste Rodin to Tweed, 1914.

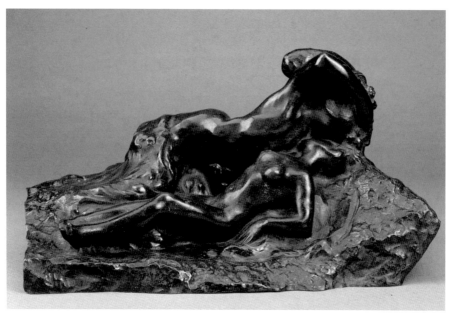

3.7 *Le Baiser du Fantôme à la Jeune Fille*, Auguste Rodin, 1895, bronze (part of the Tweed Archive).

he is now under-appreciated and under-estimated both as an artist in his own right and for his role in promoting Rodin. It is clear that Tweed was an important figure in Rodin's art historical legacy. However, the last word should go to Rodin, who in a letter written to Mrs Tweed in 1906 said of Tweed, "I am delighted that Tweed is beginning to become the great sculptor that he will be. I will try to please him whenever I can. He is a real friend and I will try to become one to him' **(3.7)**.[26]

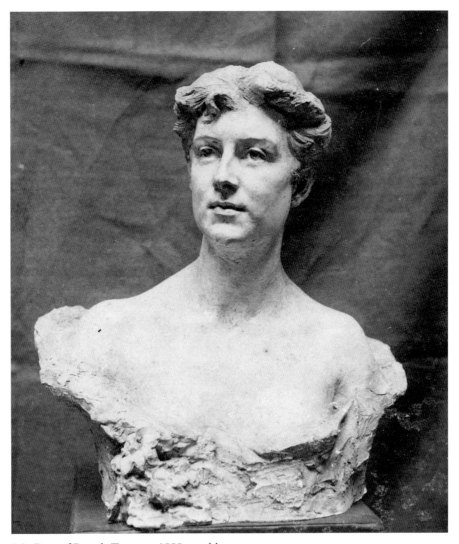

4.1 Bust of Pamela Tennant, 1899, marble.

4 Portraying the Empire

The Souls and other aristocratic patrons

Tweed's interests and activities on the continent did not distract him from pursuing a successful career in London, the mainstay of which was portraiture. At the end of the nineteenth century portraits were the most numerous type of sculptural objects produced. Patrons were far more likely to commission portrait busts than to consider purchasing imaginative works. As well as personal portraits, works were often commissioned by organisations or committees who wished to have a likeness of a connected figure to put on display. These commissions could also be associated with public sculpture projects; a portrait bust would often be produced in preparation for a larger full-scale work. Portraiture was an incredibly commanding way of displaying one's image and much sought after by those able to commission such luxuries. Frequently a sculptor had to balance the expectations that he would produce a vivid likeness with the egos of powerful and demanding people. Tweed seems to have been diplomatic and charming enough to do this successfully. He worked for some of the most fashionable and influential families of the period, being commissioned alongside artists such as George Frederic Watts, Edward Burne-Jones and John Singer Sargent, all of whom he was acquainted with.

In 1897, the Prime Minister of the Cape Colony, Cecil Rhodes, and Dr Starr Leander Jameson, an administrator for the British South Africa Company, were called back to London to give evidence at the government inquiry into the Jameson Raid. Tweed had already been working on commissions for Rhodes' home in Cape Town, and, remarkably during his stay in London Rhodes sat to allow him to start his portrait. Through Rhodes, Tweed was also introduced to the Conservative MP and future Undersecretary for War, George Wyndham, who was sitting on the committee of the inquiry. A few years later Wyndham was one of the first people to purchase a cast of the statuette based on Tweed's full-scale public statue of Cecil Rhodes.[1] At the time Wyndham was 34 and MP for Dover and ten years into his

notorious marriage to Sibell Grosvenor. Both men became crucial patrons and supporters of Tweed's career.

George Wyndham's father, Percy, was an avid collector of art and his son was no stranger to artistic circles. George Wyndham was a member of the aristocratic group – the Souls – a loosely knit but distinctive social group that flourished from the late 1880s until the 1920s. They were made up of several groups of siblings from well-known aristocratic families including the Wyndhams, Tennants, Grenfells and Elchos. Relationships were complicated within the group, many members married each other and later in the twentieth century many of their children also intermarried.

The Souls patronised the leading artists of the day. The Wyndham's family estate of Clouds in Wiltshire was decorated by Morris & Co and hung with paintings by Watts, Burne-Jones and Alma-Tadema. George Wyndham's parents, Madeline and Percy, were connected to the circle surrounding Leighton and Watts at the Holland Park Estate. His mother Madeline was painted by Watts in 1877, resplendent in a dress covered in sunflowers and advertising her allegiance to the fashionable Aesthetic style of Oscar Wilde and his contemporaries. Madeline Wyndham also commissioned Sargent to paint a group portrait of her three daughters in the late 1890s at the same time that Tweed was working on the bust of the youngest, Pamela Tennant. Madeline Wyndham wrote to him twice in 1902, on both occasions trying to arrange a time to bring Mr and Mrs Watts to his studio to see his work.[2] This, for Tweed, must have been a great honour, as in the early years of the twentieth century Watts was revered as one of the most important artists alive.

Tweed worked for at least five members of the Souls including George Wyndham, his sister Pamela Tennant (Lady Glenconner) and George Curzon. These patrons later gained him other commissions from the wider Edwardian aristocracy. George Wyndham was Tweed's first patron from the group and certainly seems to have opened the door for other commissions. The bust that Tweed produced of Wyndham does not seem to have been a direct commission but more likely a sketch that he started in Wyndham's company and worked up subsequently. The bust was mentioned as being in his studio in his 1898 interview with Roy Compton in *The Idler*.[3]

In the same year that Tweed started modelling George Wyndham's bust he received a letter from his old architect friend Detmar Blow who famously later became in the early twentieth century Pamela Tennant's 'pet' architect:

> Edward Tennant would like a bust of his wife Pamela if you have time to do it? And could go for a few days in the autumn to Stockton. They would be pleased if you would come with me to see their pictures …

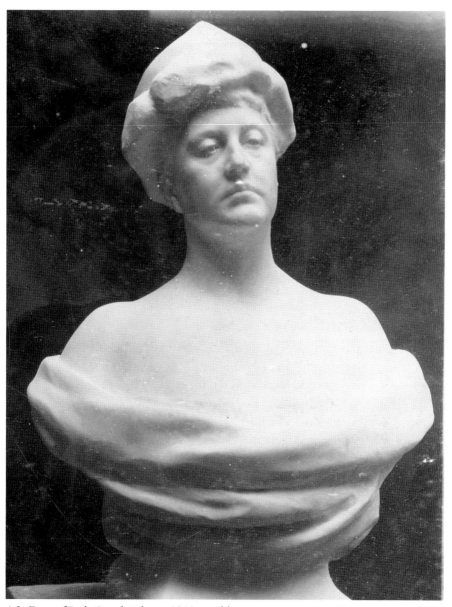

4.2 Bust of Lady Londonderry, 1909, marble.

Have just been staying with them at Stockton – George Wyndham was there + Lady Grosvenor + Leconfield and a great family gathering for the christening of the son and heir on Sunday. Mr George and I stood for the godfathers.[4]

Edward Tennant had married Pamela Wyndham in 1895. Both were

4.3 Bust of Lady Beauchamp, 1910, marble.

siblings to central members of the Souls, Pamela Wyndham being George Wyndham's younger sister and Edward Tennant being the brother of Margot, Laura and Charty Tennant, all destined to make good marriages to important members of Edwardian politics and society. The Tennant marriage was not a happy one and after the death of her husband she married her lover Earl Grey.[5] While these biographical anecdotes may not seem particularly relevant to any sculpture commission, Tweed would have had to work round these complicated and delicate relationships. His obvious, charming diplomacy meant that he successfully completed works for many aristocratic families. He took the Tennant commission and presumably visited Stockton. The sitter Pamela Tennant wrote to Tweed in May 1898; it was long and gently critical of her portrait with suggestions for improving it **(4.1)**. She wrote:

> My mother did like the bust; but I think her criticism right as to the expression in the brows + eyes. I have often said so before, have not I? and I don't think it would necessarily weaken the work or make it 'pretty' as you said if you made my eyes look happier.[6]

In August 1899 Tweed's portrait bust was not finished and the clay fell apart although he had already cast it in plaster so that losing the clay did not mean the end of the commission.[7] However, at the end of the same year Edward Tennant wrote to him to tell him that he would not pay for the marble needed for the next stage of the commission as 'the bust of Mrs

Tennant is not sufficiently satisfactory in its present condition to warrant it being put into marble'.[8] This was one of many occasions when Tweed had to placate his demanding clients, which he did.[9] The work on the bust seems to have taken several years as Tennant did not write about the delivery of the bust until 1904. He asked him to have it delivered after exhibition, probably at the Royal Glasgow Institute and he was pleased Tweed was getting other commissions as a result of sculpting his wife.[10] In the last letter dated only four days later he agreed to Tweed exhibiting the bust at the New Gallery, London.[11]

The Tennant bust is typical of many of Tweed's portrait commissions; the recommendation from another party, the sittings at a country estate and the negotiation about the state of finish or work on the piece, followed by a generally successful exhibition at major national exhibitions and smaller London spaces.

In 1909 Tweed exhibited his bust of Lady Londonderry at the Royal Academy to widespread acclaim: a critic in *The Academy* wrote of the work:

> To critics who regard sculpture as the art least capable in modern hands of expressing modern life, and therefore approach it in its present form with an attitude of mind quite different from that in which they approach it from its beginning until after the debasement of the Italian Renaissance work, Mr Tweed's portrait-bust of Lady Londonderry in marble will be welcome as a successful example of its modern power. Mr Tweed has not before equalled the correct modelling and vigorous vitality of this bust.

4.4 Bust of Lord Beauchamp, 1910, marble.

4.5 Sketch of George Wyndham, *c*.1897, sketchbook page.

Independent to any resemblance to the subject, which the spectator may not have been in a position to judge, the bust of itself creates an imperial impression which is very unusual in modern busts **(4.2)**.[12]

Another figure who admired the Londonderry bust was George Wyndham, who again provided Tweed with commissions connected to his family. Wyndham wrote to him in 1909:

> Your bust of Lady Londonderry is a great thing, which you have made. It is true and beautiful, and a great thing finely done. I went to see the model after tea + found that Lady Londonderry was as pleased as I was stunned. I dined with my wife's daughter Lady Beauchamp. I should like you to do her + her husband, Beauchamp.[13]

Wyndham had courted and married Lady Sibell Grosvenor in 1887. At the time, as heiress to the Westminster estate, she was one of the most eligible single women in Britain. Her first husband had been the 2nd Duke of Westminster and with him she had three children. Her second daughter, Lettice, married William Lygon, 7th Earl Beauchamp in 1902 and it was of her and her husband that Wyndham wished Tweed to portray. The resulting busts themselves are still on display at Madresfield Court, the Beauchamp country estate in the Malvern Hills. In 1910, the year following Wyndham's commission, Beauchamp was made First Commissioner of Works and was heavily involved along with Tweed in the siting of Rodin's *Les Bourgeoisie de*

Calais near to the Houses of Parliament. He was also later involved in the commissioning of the House of Lords' War Memorial, a work eventually produced by Tweed **(4.3, 4.4)**.[14]

The busts of Lord and Lady Beauchamp are both in marble and are typical of the head and shoulders portraits of many of Tweed's aristocratic portraits. Curiously the pair are not, however, matching. Lord Beauchamp is shown in the nude. Lady Beauchamp, on the other hand, is shown in a dress that is clasped together by a brooch, her hair is up and she looks as though she is to attend a party. Tweed's decision to depict Lord Beauchamp with bare shoulders is an interesting one as it makes a marked contrast between the two busts. There was a precedent for choosing to portray Lord Beauchamp in this way. Rodin depicts both Lord Howard de Walden and George Wyndham without clothes but this is the only portrait bust by Tweed that does not include drapery of some kind. It may be that his priority was simply to flatter his sitter as the addition of a collar, tie and jacket would have accentuated the roundness of his face, highlighting his stout figure. Tweed did not change the Earl's figure but he chose a way of depicting his bust that enhanced the shape of his face and body.

What is also clear from Tweed's portrait busts is that he had a flair for capturing the likeness of a person in bronze or marble, with Rodinesque techniques of modelling giving his busts texture and life. Both Tweed and

4.6 Bust of George Wyndham, 1897, clay in studio.

4.7 Letter from George Wyndham to Tweed, 1909.

Rodin's style of portraiture captured a great deal of the sitter's personality but in subtly different ways. Of the two Tweed may have been the better at doing this. A comparison can be drawn between the busts made of George Wyndham by each artist, Tweed's in 1897 and Rodin's in 1903. Rodin's bust is characteristically linear, the neck, shoulders and head all face forward and the bust stares straight out at the viewer. The eyes are slightly deadened and the finish seems overly smoothed, particularly on the skin of the chest. However, Rodin has infused what is quite a weak, thin body and head with a sense of power and intelligence **(4.5)**. Tweed's bust takes a slightly different approach. The head is tilted to one side in a quizzical manner, the suggestion of curiosity continues in the eyes which gaze at the viewer questioningly. The work seems lighter than Rodin's and depicts a man with a brighter view of the world. This may be due to its earlier date; the bust was made before Wyndham took on the difficult position of Secretary for Ireland. The slight smile suggests that this is a man enjoying life and perhaps taking pleasure in the conversation with his artist **(4.6)**.

Wyndham had very specific ideas about the multiple portrait commissions he gave Tweed:

> The English painter, or sculptor, has a chance *in his models*. It is a passing chance. The 'Gentry' of England – as a type – are interesting; probably we have done what we are here to do. We are a survival. By 'we' I mean the countryside English gentry.
>
> When we are beaten by Cosmopolitan Finance if we lose; or merged in

Imperialism if we win – we shall in either case disappear and be blended in what has to be. But typical examples are worth a record by the Art of their day. I would like you to make that record. Let the coming world, of oriental finance, + of Colonial Britons, know what the old people were like, who were nurtured for centuries on English acres **(4.7)**.[15]

This excerpt from a letter Wyndham to Tweed in 1909, the same letter in which he commissioned him to produce the busts of his step-daughter and husband, says a lot about how Tweed's patrons viewed him. It may also reflect how Tweed saw his portrait commissions and goes some way to explain why he has been overlooked as a portrait sculptor. He was entrusted by members of the establishment as a 'safe pair of hands' to depict the 'right sort of people'. The decline of the aristocracy in the twentieth century meant that the families that Tweed represented lost power and consequently their portraits lost relevance.

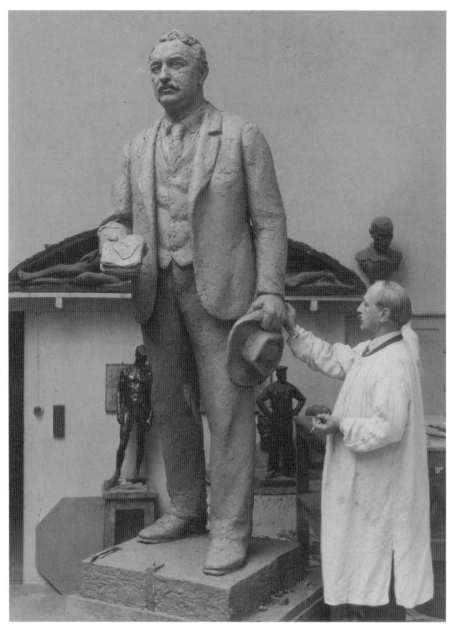

5.1 Statue of Cecil Rhodes for Mafeking, *c.*1932 clay in studio.

5 Mediating Cecil Rhodes: Edwin Lutyens and Arthur Collie

In amongst his portrait commissions Tweed worked to further his career in other parts of the globe. On returning from Paris in 1894 he socialised with a group of artists and architects in and around London. At the end of the nineteenth century there was an interesting tension existing in certain forms of the art. Unlike painting, sculpture and architecture still relied heavily on a patron-led and workshop-based system that had not changed recognisably since the fifteenth century. That is not to say there had not been pioneering changes in these art forms. The resurrection of the 'lost wax' process of casting and the industrialisation of such processes at the end of the nineteenth century had made an impact but the success of sculptors and architects still depended on commissions and an inherently collaborative process.

Tweed had to negotiate the politics surrounding this emphasis on patronage; with no private income he had to gain commissions in order to live but also to fund the personal sculptural interests, seen in his small ideal works. He formulated networks of patrons, aristocratic and other, and relied heavily on the social, family and political links already established by his clients. To commission sculpture at the turn of the twentieth century was no small undertaking and an overwhelming majority of Tweed's patrons were of the upper social classes or committees of upper middle class 'activists', able to raise subscriptions for commemorative busts and memorials. His friends worked using similar methods and often networks and connections overlapped as artists worked together in order to gain the most from prospective patrons.

Edwin Landseer Lutyens was born in March 1869, two months before John Tweed, just one of many parallels in their respective careers. Lutyen's

father, Charles, was a painter, mainly of landscapes and horses and worked for the fathers of several of Tweed's later aristocratic clients, including Percy Wyndham. In an irony that typifies the closeness of artistic circles and communities of the period, Charles Lutyens used the stables behind his London house in Onslow Square, Kensington as studios along with Edwin Landseer and the sculptor Baron Marochetti.[1] Later an architect turned the stables into purpose-built studios known as The Avenue Studios or Sydney Mews, after the original street name. Nos 12-14 were leased to John Singer Sargent and in 1903 Tweed took no. 8 to work on the Wellington Monument.

Unlike Tweed, Lutyens had a family with an artistic background that made it less problematic for him to become an architect, his family also helped to support him financially. He joined the South London School of Art in 1885, three years after Tweed started classes at the Glasgow School of Art. He only stayed at the school for a couple of years, before becoming an articled pupil in the office of the architect Ernest George. Although Tweed had a head start on his artistic training, by the time he was attending classes at Lambeth in the early 1890s Lutyens was beginning his professional career.[2] It is not clear from the letters of the two men when and how they met but it may have been simply that both were two young artists in Chelsea at the same time. Tweed was living in Cheyne Row, a short distance from Onslow Square where Lutyens was still living and running his fledgling practice from a spare bedroom. However, Lutyens' biographer Jane Ridley states that Lutyens in 1890:

> belonged to a circle which included Detmar Blow, Arthur Collie, a Bond Street art dealer, and the sculptor John Tweed. They would meet on Saturdays at an inn named The Cricketers near Thursley, and occasionally Ned [Lutyens] went with them to a meeting of the Art Worker's Guild.[3]

Collie and Lutyens later played significant roles in Tweed's introduction to the patron who would launch his career, Cecil Rhodes (5.1). However, before then, the three friends met socially and attended the Art Workers' Guild. Tweed had been introduced to the Guild while an assistant in Thornycroft's studio. By the 1890s it was housed in Barnard's Hall in Fleet Street and was attracting many of London's finest artists both to speak and listen.[4] The architect Detmar Blow, became a member in 1892 but Lutyens joined fully in 1903 and Tweed finally in 1904.[5]

Collie was not a member of the Guild, although associated with it. Collie came up with plans for selling statuettes of major sculptures as decorative objects, reasonably priced and produced in limited runs in a similar way to prints. In line with the industrialisation of the processes of producing

sculpture, Collie tried to commercialise the sale of sculpture, from one-off purchase to widely available collectibles. This approach had already been a success in the Parisian art market and created a new group of consumers of art; the middle classes able to afford their own small scale artworks. Considering sculpture or sculptors as brands may seem to be a modern view of turn of the century sculpture but a need to sell British sculpture was recognised at the time. Sculpture critic, Edmund Gosse, in his 1895 essay *The Place of Sculpture in the Home* grouped together the leading members of the New Sculpture in order to promote an identity and a brand that he encouraged people to buy into. He encouraged this by providing the name and address of the dealer who sold such statuettes.[6] The recommended dealer was Arthur Collie.[7]

Sculpture for Cape Town

The first letter from Lutyens to Tweed in March 1893 asked if he would be interested in producing the figures of the four Evangelists and their attributes for a reredos screen that Lutyens was designing although the commission did not come to fruition. The reredos was to be made in oak and Lutyens assured Tweed that he realised that wood was not his preferred medium but if he would model the figures Lutyens would provide the carver.[8] Later the same year, while Tweed was in Paris, Lutyens wrote to ask if he would like a commission for the Prime Minister of the Cape Colony, Cecil Rhodes.[9] Lutyens already knew Rhodes' architect, Herbert Baker.[10]

Rhodes wanted a bas-relief panel for the gable of his newly built residence in Cape Town, Groote Schuur. The letter from Baker to Lutyens survives amongst Tweed's papers, possibly forwarded by Lutyens to Tweed. Baker explained Rhodes' requirements and included a sketch of the subject matter.[11] The panel was to depict the landing of Jan van Riebeeck (considered the first European to land in South Africa) at the beach next to Table Mountain. This letter shows not only how Baker and Lutyens mediated Tweed's role as artist but also how little artistic control he had over this early commission but it seems that Tweed did not argue. Given the celebrity of his patron it may have seemed to him a small price to pay for what was to become an incredibly profitable relationship. In Baker's memoir of Rhodes, published in 1934, he simply stated that 'John Tweed, then a young Scotch [sic] sculptor, since to become famous, was chosen'.[12]

At this point Collie was also employed by Rhodes to provide art and antique furniture for the interiors and in 1895 he moved out to South Africa to supervise the decoration of Groote Schuur.[13] Collie was employed by Rhodes through Baker and, while it is not explicitly mentioned, it is

possible that this was another of Lutyens' recommendations. Letters Collie sent Tweed were gossipy accounts of the politics in Rhodes' inner circle but also showed that Collie was invested in helping Tweed gain commissions.[14] Collie's enthusiasm resulted in Rhodes' purchase of Tweed's statuette of the Scottish poet Robert Burns and his later commission for the life-size statue of Jan van Riebeeck. The Burns statuette, along with several other commissions from or to do with Rhodes, caused Tweed problems. The prominence he was to receive as Rhodes' sculptor did not come without a price.

Tweed's statuette of Robert Burns began as a design in 1894 for a competition to produce a statue of the poet for the town of Paisley. 1896 was the centenary of his death and all over Britain, but especially in Scotland, Burns was being commemorated with statues. Tweed did not win the competition; his design did not even make the top three. His future colleague at Thornycroft's studio, Charles John Allen came third and the Scottish sculptor, Kellock Brown, was second with the well-known London based sculptor, F.W. Pomeroy, first.[15] Tweed, however, worked his design up into a statuette around three-feet high and proudly circulated photographs of it around his admirers in Glasgow and London including Colin Rae-Brown, the Vice-President of the London Burns Club of which Tweed was a member. Rae-Brown wrote to him in 1895:

> I think you ought to have the Burns reproduced in the Graphic or Illustrated [London News]. The world ought to know that such a thoroughly characteristic and artistic Burns has been produced. Burns as he undoubtedly was – not a mere painter's Burns![16]

The work had already come to the attention of Cecil Rhodes, who wanted to purchase the work. He may have seen it when he visited Tweed's studio at the time of the commission of the Groote Schuur panel in 1894.[17] Tweed, however, refused having already promised the work to the Scottish author, Robert Louis Stevenson, and was planning through their mutual friend, Charles Baxter, to send the work to Stevenson in the South Seas. Rhodes was undeterred and when Stevenson died suddenly at the end of 1894, he began again to pursue Tweed for the Burns. Collie, by this time living in Groote Schuur, arranged the purchase, acting as both dealer for Tweed and buyer for Rhodes. Collie also seems to have explained to Rhodes that a sculpture's design during the period usually remained the sculptor's property; Tweed would be well within his rights to continue to produce statuettes of the Burns and sell them to other people. This Rhodes could not have. The Burns was to be his and no one else's, and he therefore

ordered Tweed to sell him the other bronze of the Burns statuette and the plaster maquette. As soon as news of Stevenson's death reached South Africa Rhodes had one of his representatives, the painter Hubert Herkomer, write to Tweed in a letter dated 13 December 1894: 'Mr. Rhodes now wishes me to ask you what your price would be for the plaster model (in addition to the bronze), with all rights to it, so that he can be the sole proprietor of your statuette of 'Burns', let me know by return mail.'[18]

This, in the late nineteenth century, was practically unheard of and to begin with Tweed would not agree to the sale of the rights along with the statuette. A second letter from Herkomer dated January 1895 states:

> I am bound to tell you that the arrangement regarding the copyright of your 'Burns' does not please or satisfy Mr. Rhodes. He does not wish you to repeat it, either the same size, smaller or <u>larger</u> [original emphasis]. I have done all I can to make clear your position as an artist, but he sticks to his idea of wishing to be the only possessor of the statuette'.[19]

Tweed eventually agreed and appears to have been paid to do so. The bronze was sent to South Africa in 1896 when Collie reported on how he had arranged for it to be displayed:

> After much discussion of positions for it, I put it in the corner of his [Rhodes] library – (where we all sit) – on the top of a high revolving bookcase. The room is panelled with oak and this is really a splendid background for it. You <u>have</u> [original emphasis] got a lovely patina on it! It has not suffered in the slightest by the journey and in this air the surface will improve (if possible) rather than depreciate.[20]

The second bronze was sent out to South Africa at a later date, which Rhodes presented to his deputy Dr Jameson. The plaster does not seem to have been sent as it was still in Tweed's studio after his death in 1933. In the 1920s Dr Jameson's copy was found in the shop of the art dealer, Arthur Spencer, and he bought the work back for £50,[21] something that angered him considering the wrangling that took place over the original purchase. That copy is thought to be the one now belonging to the National Library of Scotland in Edinburgh. The work was one of Tweed's most successful pieces. In 1934, the Director of the Tate Gallery J.B. Manson wrote on behalf of the Chantry Bequest to Tweed's daughters that the Bequest wished to purchase a bronze copy of the Burns for the nation.[22] The plaster had not been in a condition from which a casting could be made. In the end the Chantry Bequest purchased a bronze model of the statue of Lord Clive, now in Tate Britain, London.

Throughout the discussions about the purchase of the Burns statuette

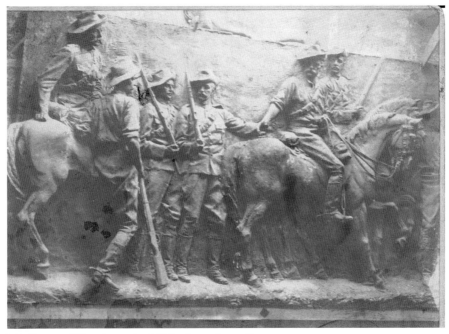

5.2 Shangani Patrol panel, *c.*1895, plaster in studio.

during 1894 and 1895, Lutyens continued to have a part in the various African projects of Baker and Collie, particularly the Groote Schuur panel. While Collie organised the display of the Burns, Lutyens sent Tweed photographs of 'Hottentots' in order for him to faithfully represent the indigenous Africans on the relief.[23] Lutyens also seems to have been in charge of paying him for this work for Rhodes; a letter from Lutyens to Tweed dated February 1894 apologised to Tweed but told him that he was not authorised to pay him any more than £100 until he gave Rhodes an exact price for the finished Groote Schuur panel, including casting, burnishing and shipping.[24] The panel arrived in South Africa in the autumn of 1895.[25] This too had its problems as Collie related in a letter from November:

> I told him [Rhodes] what you had written to Baker and that it was the <u>founder</u> who had 'been and gone and done it'. Moore had inscribed his own name all along the top side of the boat – and your name and the date (less distinctly) on the right hand base of the panel. I hammered down Moore's inscription as best I could, but it was very deeply cut and it is still quite readable. Of course, when the panel is up it will really never be seen, but still Rhodes will <u>not</u> have dates and names, he says, on any of his things [original emphasis throughout]![26]

After the Groote Schuur panel Tweed became involved in the plans for the memorial to the Wilson or Shangani Patrol. The Shangani Patrol were a group of 34 men under the command of Major Wilson who were separated from a larger force involved in Dr Jameson's invasion of Matabeleland in 1893. Acting as the forward patrol of a force pursuing the King of Matabeleland, Lobengula, Major Wilson decided to go ahead in the hope of capturing the African King. His force was heavily outnumbered and surrounded and all the men lost their lives.[27] It was one of the pivotal events of the 1890s, along with the Jameson Raid of 1896 that preceded the outbreak of the Second Boer War and that led to Rhodes resigning his premiership in 1897. Collie seems to have been feeding Tweed the plans for the memorial so that he could have a good idea of what Rhodes wanted. In May 1895 he wrote from Groote Schuur to tell Tweed that Rhodes had decided against a plan for medallion portraits and was interested in having bronze panels instead **(5.2, 5.3)**.[28]

Between Tweed, Collie and Lutyens the obelisk plan seems to have been unpopular and in March 1895 Lutyens told him not to interfere in the discussion of the memorial and to let Baker sort it out. The tone was friendly and jokey but Lutyens told Tweed to 'make a bonfire' of his model. Lutyens included a sketch of an obelisk with a comment in French underneath, 'C'est l'obielisque, mais ce n'est pas La Tweed' (It is the obelisk but it is not Tweed) (5.4).[29] Baker, however, wrote to him in October 1895 describing the local granite known as 'Paarl', 'capable of cutting into huge monoliths like the Egyptian. Why should not your obelisk at Zuin Matabye be monolithic? I don't know if the granite of Matabeleland would split so. The ancients would have carried it up from here!'[30]

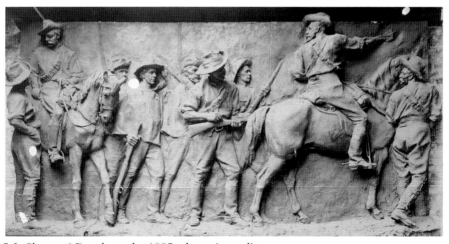

5.3 Shangani Patrol panel, *c.*1895, plaster in studio.

5.4 Letter from Edwin Lutyens to Tweed, 1895.

Robert White wrote to Tweed in April 1895 on behalf of Rhodes with six carefully numbered points about his designs for the Shangani Memorial. These included, as Collie had already pointed out, that Rhodes now preferred the idea of the men being portrayed in full-length portraits on relief panels rather than medallions which had been the original idea. The sixth point dealt with the overall shape of the monument itself:

> Mr Rhodes would like you to send the measurements of the obelisk above the plaques. He thinks the present superstructure too stumpy and thick. He remembers seeing the obelisk of Queen Hatshepsut at Thebes (temple of Karnac) which is 105 ft and tapers gracefully – , in fact does not look podgy, which might be said of our obelisk. He actually says, 'Could you not put your plaques underneath Queen Hatshepsut's monument, or is this rather too small for the length required for so many figures'.[31]

Rhodes seems to have wanted his architect to design the architecture and his sculptor to design the sculpture and expected the two to marry beautifully, despite the continental distance between the two of them. The finished memorial was supposed to be a collaboration between Baker and Tweed and was one that both of them came to look back on with unease. Neither could agree on how to design the memorial and eventually Tweed got his architect friend, Detmar Blow, to design the architectural element. This plan too, was scuppered when Baker revealed Rhodes' dying wish to have the memorial near to his grave at World's End in the Matopos Mountains in South Africa (now part of the Matobo National Park). The original location had been close to where the patrol had lost their lives in Rhodesia. This changed the terrain from a flat base to a steeply sloping one, Baker again took over the commission and he and Tweed had very little discussion about the memorial that was eventually unveiled in 1903. Tweed certainly felt that Baker's choice of architectural frame for his panels did not show them off to their best advantage and at worst sabotaged his efforts on the relief panels.[32]

During this period of African commissions in late 1896, Tweed was asked by a committee of townspeople from the Rhodesian town of Bulawayo to design a statue of Cecil Rhodes **(5.5)** because he was the only sculptor to have had sittings with Rhodes when Rhodes and Dr Jameson visited London in 1894.[33] The work for the statue's design was therefore on-going during a period when Tweed was working on the Shangani Memorial, the statue of van Riebeeck and smaller decorative commissions for Groote Schuur. Rhodes gave his blessing to the statue and even gave Tweed some

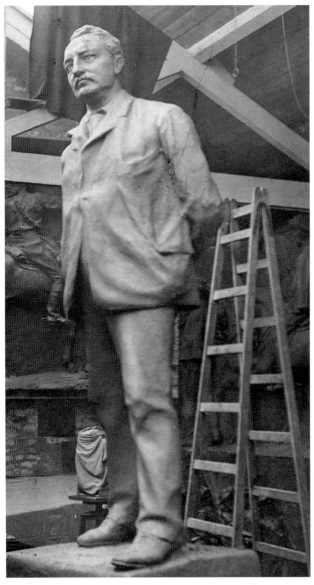

5.5 Statue of Cecil Rhodes for Bulawayo, c.1896, clay in studio.

extra sittings when he was in London in February 1897 but by April Rhodes had been dissuaded from the artistic merit of his portrait and demanded the work be stopped.[34] Tweed refused as the work was from a third party and not commissioned by Rhodes himself; a contract for the statue had already been signed and Tweed was due to be paid £1,750 for the work. In refusing to destroy the work Tweed incurred Rhodes' wrath and the monthly instalments for the other African commissions stopped.[35] Despite advice from Baker to do as Rhodes wished unless he wanted Rhodes to

ruin him, Tweed eventually took on his own solicitor who pursued Rhodes for all monies owed and Tweed was successful. Rhodes was not able to renege on the various contracts. However, by this point it was 1902 and Rhodes died in the March **(5.6)**.[36]

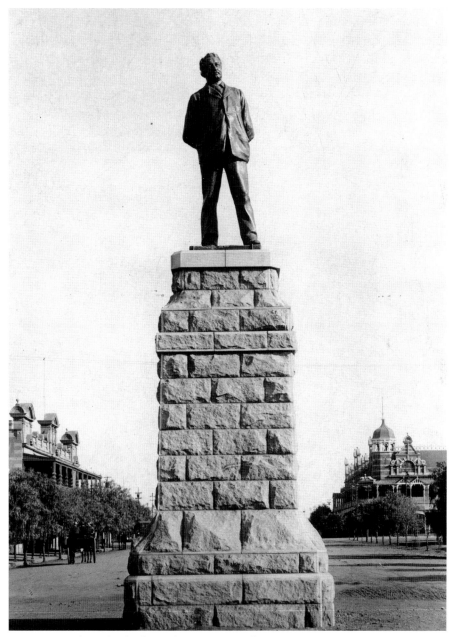

5.6 Statue of Cecil Rhodes, Bulawayo, *c.*1902, bronze.

The statue of van Riebeeck had been erected in 1899 and the Groote Schuur panel was *in situ* on the building that housed the Burns statuette **(5.7)**. The Shangani memorial was eventually unveiled in 1903 at the same time as the Rhodes' statue in Bulawayo. Other African commissions that were undertaken included a bust of Chief Khama, the leader of the Bechuana people and ally of Rhodes, and a statue of Alfred Beit, the Randlord who helped to finance Rhodes' forays into Rhodesia **(5.8)**. After Rhodes' death Tweed gained many commissions from the prestige of being the only sculptor to have worked on Cecil Rhodes' portrait from life; he produced several versions of the bust and completed two more life-size statues for Salisbury and Mafeking in Rhodesia. The intense period of work from 1893 to 1903 saw Tweed emerge as a sculptor of national, colonial and

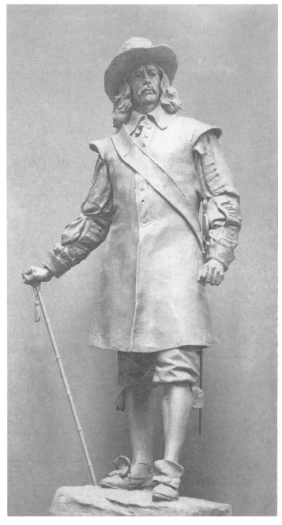

5.7 Statue of van Riebeek, *c*.1895, bronze in studio.

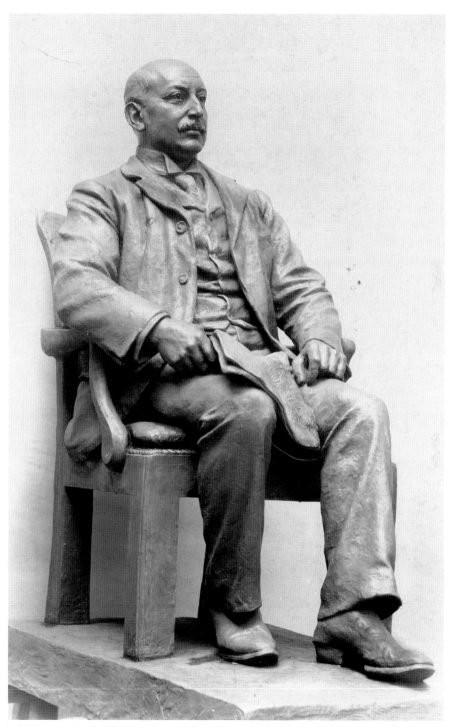

5.8 Statue of Alfred Beit, unknown date, bronze in studio.

international standing and as his correspondence shows this was as much due to his close collaborators and supporters as to his artistic prowess.

Baker and Tweed were never to work closely together again. The Shangani Memorial soured their friendship to the point that Baker wrote a rather scathing rebuttal to *The Times* obituary of Tweed in 1933.[37] Lutyens, however, continued to work with both men, famously designing New Delhi with Baker and staying friends with Tweed, although as both men's reputations grew they no longer relied on one another for commissions. The last letter from Lutyens in the Tweed Archive, dated 1921, asks for help with a design for an unknown object, of which he has sent sketches separately and asks if Tweed can do it in marble.[38]

Tweed's career was peppered with negotiations and collaborations with artists, craftsmen and patrons. It was his ability to propagate these networks that helped to ensure his successful career.

6 Sculpting the Empire

Public statues are the works for which Tweed is best known today, outside, on our streets and parks, mainly in London but also other cities. During the later nineteenth century there was a huge increase in the numbers of statues erected in urban spaces. Described as 'statuemania', the phenomenon has been linked to the emergence of a bourgeois class and to the increased nationalism of late nineteenth-century Europe. As society became more meritocratic, there was a need to commemorate significant individuals from a wide variety of backgrounds and varying walks of life, not just heads of state who had been celebrated in earlier periods.

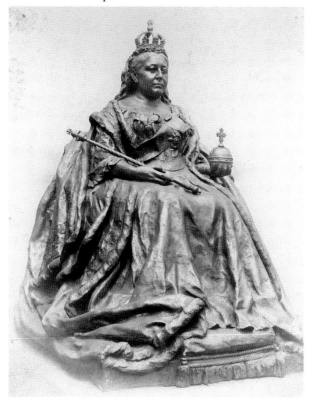

6.1 Queen Victoria,
*c.*1905, bronze in studio.

6.2 Queen Victoria in Aden, *c.*1906, bronze.

'Statuemania' subjects could be either contemporary or historical and include politicians, military leaders, artists and scholars.[1] All were viable candidates, advertising the nation's cultural and political capital, not just to its own citizens but also to other states. In Britain's case this also meant promoting the nation in its colonies. Public statuary was a highly visible way of imprinting the ruling nation literally onto a colonial landscape. Figures chosen to grace the urban spaces of London and its colonies were often connected to the Empire. While there was a wide range of subjects, statues of Queen Victoria were popular in Britain and her colonies. Tweed himself produced a statue of Victoria for Aden (now part of the Yemen) **(6.1, 6.2)**. Pioneers and explorers from the eighteenth and earlier years of the nineteenth centuries were also considered to have been empire builders and were commemorated accordingly.

Tweed's work with public statues became well known after the controversy over the completion of the national memorial to the Duke of Wellington in St Paul's Cathedral. The *Wellington Monument* had been begun in 1856 by the sculptor Alfred Stevens (1818-75) **(6.3)**. It had been his most prestigious commission and the convoluted architectural monument had not been finished when he died. The last part was an equestrian portrait of the Duke which only existed as a broken plaster. It had never been cast in bronze. Working on another artist's sculpture was relatively unusual but this was a high-profile project. Tweed's job was to repair the plaster and then prepare it

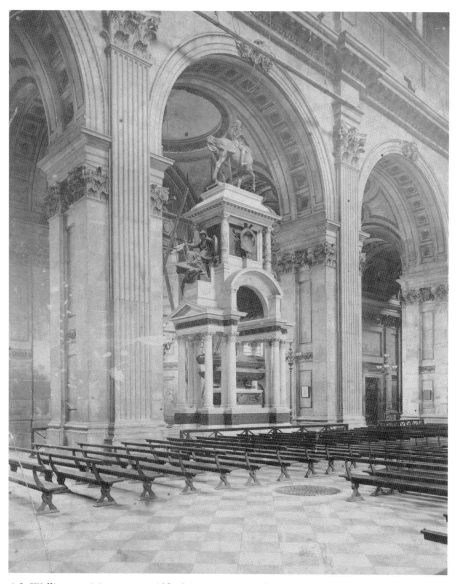

6.3 Wellington Monument, Alfred Stevens, St Paul's Cathedral, *c.*1912, bronze and marble.

for casting. In essence it was a workman's job not an artistic endeavour but it required a workman who understood the complicated processes inherent to bronze-casting and who could preserve Stevens' vision **(6.4)**.

Tweed's appointment in 1903 to complete the *Wellington Memorial* had been fraught with controversy. He was commissioned by a small committee based at the Chapter of St Paul's. The RA felt that they should have been

61

6.4 Equestrian portrait of the Duke of Wellington, Alfred Stevens, *c*.1905, plaster in studio.

consulted on the appointment and claimed Tweed was too inexperienced to finish the work. The process of completion was long (nine years in total), complicated by a lot of criticism and defence of his abilities. However by the time the *Wellington Monument* was unveiled in 1912, he had produced several different public statues both in Britain and the Empire and had two other statues to be unveiled that very year.

Captain Cook

Captain Cook lived during the mid-eighteenth century, a time of massive expansion in Britain's empire; he is mostly remembered for his voyage to the South Pacific which led to his discovery of Australia for Britain. He is considered to be the first European to set foot on the continent and directly responsible for British sovereignty in the region for the next 200 years. While Cook's actions and reputation are now considered with suspicion and some unease, in the nineteenth century his story was a legend. He was not only revered for expanding the British Empire by nearly a third but he also symbolised social mobility, having been born on a small farm in Yorkshire and becoming one of the most famous seafaring explorers of all time. Captain Cook was chosen as an exemplar, rallying a modern British

imperial ideology and representing a type of masculinity that was felt to be lacking and endangered by modern society at the start of the twentieth century.

The idea of a statue of Cook for London was proposed in 1909, during a period when London, as capital of the Empire, was already the subject of plans to alter its appearance. The Victoria Memorial and the changes to The Mall, in progress in 1909, were seen as the beginning of a programme of enhancement to make increasingly visible London's imperial role. It was felt that the city lagged behind other European imperial cities because it lacked impressive architectural vistas and its buildings and public spaces did not represent the history of Empire or embody Britain's prestige as a world power.[2] The medieval layout of the city meant that long boulevards and avenues were not possible; London seemed unfashionable especially when compared with Haussmann's redesign of Paris.

The Captain Cook committee had the Duke of Devonshire, President of the British Empire League, as its president, and the Prince of Wales as its honorary chairman. Following the collection of public subscriptions a competition was opened for proposals; several sculptors entered including Thomas Brock, Bertram Mackennal and John Tweed.[3] In May 1911 it was announced in *The Times* that the Cook Memorial had won an important site for its project, in front of the newly refurbished Admiralty on The Mall, a route integral to the planned redesign of London. The commission had been awarded to Thomas Brock.

The selection of Brock for the memorial was unsurprising given that he was responsible for the Victoria Memorial and most significantly the statuary on the exterior of the Admiralty. The decision preserved the continuity of the redevelopment of The Mall where the Cook statue was destined to stand. By this period, Brock was a successful sculptor who had received many large scale commissions. He had been a pupil of John Henry Foley, a successful mid-century sculptor and following Foley's sudden death in 1874, Brock completed much of Foley's unfinished work. He had also worked as an assistant to Frederic Leighton, President of the Royal Academy from 1878. However, the choice for the Cook memorial and the way it had been agreed led to some controversy. To choose a sculptor because of the locations of other pieces of his work angered some committee members who questioned why there had been a competition at all.

Tweed's design was not selected despite strong support by Gervase Beckett, one of the committee members. Beckett was a businessman, aristocrat, MP and editor of the *Saturday Review*. Almost immediately after Brock's selection was announced, Beckett commissioned Tweed to produce

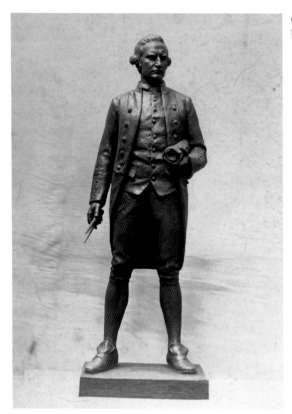

6.5 Captain Cook, *c*.1912, bronze in studio.

a Cook monument for his constituency, Whitby. The town had a special connection to the explorer, being close to his birthplace as well as the port where he embarked on his voyages. While there is no clear evidence, it seems likely Beckett commissioned Tweed to recompense his friend for a commission that he regarded as having been stolen from the rightful winner.

Tweed's statue of Cook, commissioned so quickly after the announcement of the London memorial, caused confusion in a couple of London newspapers. There was a misleading rumour that Tweed had been commissioned to produce a copy of Brock's London statue. Tweed's designs for the London site are lost but it is likely that his Whitby statue, erected in 1912, was based on his competition entry. The site was not chosen until May 1912 suggesting that it was selected to suit the statue, and not the other way around.[4] Tweed's *Captain Cook* was unveiled on 2 October 1912, just eighteen months after the London competition; Brock's statue would not be ready for another two years. By getting the Whitby statue erected ahead of Brock's, Beckett must have felt some satisfaction that his was the first one to Cook in Britain **(6.5)**.

The statue was erected on the West Cliff in Whitby in the People's Park.

Filson Young described the statue for the *Saturday Review* in 1912,'He [Cook] is not pointing or leaning or posing or gesticulating, or engaged in any form of doing – merely in being'.[5] Cook stands, arms drawn in, overlooking the sea, staring at the horizon as though he had always stood there and always will. The figure is static; his feet hip width apart, both legs straight, rooted to the pedestal. The stillness of the pose reinforces the feeling of unruffled calmness. Cook has braced himself to weather any storm. There is nothing flamboyant or theatrical about his pose which denies the statue any kind of emotional reading. It appeals to the idea of studied masculinity, the lack of movement giving the sense that the figure is always in control of his body but can respond to any situation that may arise around him. The *Yorkshire Post*, commenting in May 1913 on a model of Tweed's statue of Cook at the RA, wrote:'The figure stands on its feet with an uncompromising firmness that suggests a manly force quite in accord with what one imagines the explorer to have been'.[6] It is only the sea chart and compasses that Cook holds in his hands that place him historically, his pose and demeanour make him relevant to contemporary audiences as a type of man they should aspire to emulate.

At the unveiling ceremony many comments were made about the statue and its sculptor but the most interesting was Gervase Beckett's on how many British people viewed art and artists as effeminate. He was concerned to promote Tweed's masculinity as an artist and in doing so the masculinity of his statue:

> He (Beckett) had often wondered how it came about that so many English people looked upon art as an effeminate practice. They saw that in the popular estimate; sometimes artists were pictured as young men with yellow trousers, velvet coats, green ties and long hair. They might see his friend, Mr. Tweed, and another artist, a friend of his, who was also present, Mr. F. W. Jackson, and, if they were examined, they would find in them none of the attributes to which he had alluded. As for effeminacy, he knew Mr. Tweed was not only an expert in the art of sculpture, but also in the art of wrestling, and if anyone judged him as effeminate, he (Beckett) would recommend them to try a bout with him.[7]

Effeminacy in art was an issue of great public concern in the late nineteenth century, especially after the cult of Oscar Wilde and the Aesthetic Movement had culminated in Wilde's trial for sodomy in 1895. The Movement and its followers had been satirised by people such as George du Maurier in *Punch* and Gilbert and Sullivan in their comic opera *Patience*. These were the likely sources for the image of artists with 'yellow trousers, velvet coats, green ties and long hair'. Tweed himself was noted for the 'normality' of his appearance

which Beckett spoke about at Tweed's posthumous memorial exhibition in 1934:

> In appearance as in being John Tweed belonged to no type. The odd clothes and quaint coiffure associated in the popular mind with Chelsea were no part of his make-up. He had no thought but to put his whole personality into his work, he had no wish to appear other than himself.[8]

Public sculpture that appeared to have feminine qualities or lack masculine vitality would have been contentious particularly because such sculpture was intended to promote exemplary virtues. Tweed gained a reputation for producing statues that could not be attacked on the grounds of effeminacy and could not therefore be described as degenerate. Many of the men on committees to commission public sculpture were concerned with creating a project that not only commemorated the subject but also created an aura of masculinity intended to strengthen society symbolically. Historian Josh Tosh explains;

> ... empire was a man's business in two senses: its acquisition and control depended disproportionately on the energy and ruthlessness of men; and its place in the popular imagination was mediated through literary and visual images which consistently emphasised positive male attributes.[9]

Cook's story spoke volumes about the British Empire, about the strength of the men who founded it and how Edwardian men should not be found wanting in its defence. Statues such as the versions of Captain Cook by Tweed and Brock were intended to inspire and persuade the men of the 1900s that they too had a duty to the British Empire. In 1914 a bronze copy of Tweed's *Captain Cook* was unveiled in St Kilda, Melbourne, Australia (**6.6**). During its dedication the State Governor of Victoria, Sir Arthur Stanley, commented that, 'Nothing would have given Captain Cook greater pleasure than to see the fleet of young Australians sailing out to help the cause of the country from which they sprung'.[10] This remark given a couple of months after the outbreak of the First World War was similar to comments made by Lord Charles Beresford, two years earlier, at the unveiling of the statue at Whitby. Beresford told the local group of Boy Scouts, 'that the country would count on them in the future. The discipline they learned now would enable them to take a hand in the support and defence of the Empire if called upon'.[11] He continued that the statue would, 'remind the youth of the country for all time of a man who served his country in every sea, in the path of honour, duty and patriotism'.[12]

It is a sad irony that many of those who fought for the Empire in the

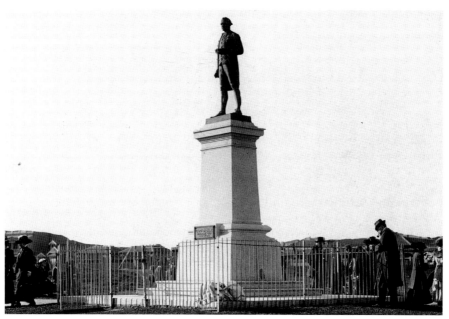

6.6 Captain Cook, St Kilda beach, Australia, *c*.1914, bronze and stone.

First World War with such patriotism would not have come home. Cook's career did not represent overtly military values, despite his violent death and the fact that his voyages were a crucial factor in the formation of the Empire; his primary aims were to gather scientific data, not to conquer or invade. However, by the early twentieth century he had come to symbolise masculine ideas of military prowess and victory for the Empire.

Lord Clive

Although cracks had begun to appear in the foundations of the British Empire by the start of the century, its heroes continued to be celebrated in sculptural commissions. In May 1909 Tweed received a telegram from Perceval Landon, who had been a foreign correspondent for several of the major national newspapers and was corresponding with Tweed in his role as secretary to the 'Committee for the Public Subscription for the Statue of Lord Clive', to say that Tweed had been awarded the commission to design and make the London memorial statue to Clive. The debate over a public, national monument to Lord Clive had begun two years earlier, in the same place as the debate over a statue to Captain Cook, the letters column of *The Times*. Sir W. Forwood, an Irish peer, wrote on 30 March 1907, that there was no monument to Clive in India or London and that his grave, in a

67

small village church in Shropshire, was unmarked except for a small bronze plaque. Forwood felt that:

> The Maiden Calcutta would be enriched if it embraced a monument to Lord Clive; Westminster Abbey would more truly reflect all that is great and worthy in England's history if it contained some appropriate record of Robert Clive and what he did to build up her Empire.[13]

The call was answered by Lord George Nathaniel Curzon, the Viceroy of India, who wrote to *The Times* on the 8 April 1907 that:

> While I was in India this neglect was frequently in my mind. Thinking that the first memorial to Clive should be the due commemoration of the famous episode (it was in truth scarcely a battle) which won the Indian Empire, I undertook the commemoration of the site of the battle of Plassey.[14]

A public subscription was started and in one year raised enough money to fund a bronze statue for London and a marble replica for Calcutta. Several leading sculptors including Tweed and James Harvard-Thomas were invited to present designs competing to produce the memorial. On 31 July 1908 Tweed received a letter from the Committee Secretary, Perceval Landon, giving him advice on how to present his design:

> May I suggest in making your sketch, do not lean too much towards the Rodin school of theory. Personally I think it is the salvation of modern sculpture but the committee will probably be afraid of it if it is too elemental and obtuse.[15]

The committee apparently liked Tweed's design regardless of his connection to Rodin and in May 1909 the *Saturday Review* (edited by Tweed's friend and patron Gervase Beckett) announced:

> We are delighted to hear that the commission for the Clive Memorial has been given to Mr. John Tweed. Better choice of a sculptor could not have been made. Mr Tweed has the character for the subject. He has the breadth and the truth, which most modern sculptor's lack.[16]

In June 1909 Tweed presented a model of his statue to the King. The site given over by the Office of Works for the memorial was of such importance that the King had to approve the chosen design before work could go ahead. Tweed began work on the sculpture but he and Lord Curzon quickly realised that the site, which was bordered by two government buildings both of which were in the process of being rebuilt, was not going to be ready for the erection of a large statue for at least four years. Work on the statue was

then delayed and eventually Tweed handed over the statue and pedestal to the Office of Works so that the statue could be erected once the building work was finished. While the Clive statue came to be one of Tweed's best known statues it was erected in August 1910 at a temporary location in front of Gwydyr House and moved to the steps of King Charles Street at a later date (**6.7**).

Tweed's figure of Clive was to be a memorial to a man who, in Lord Curzon's words, was 'one of those titanic forces that rise above the obscure surge of humility to affect the fortunes for good or evil of the world. That Clive's work was for the good of England, for the good of India, and for the good of mankind no one can reasonably doubt.'[17]

One wonders if Tweed's statue was actually almost out of date before it was unveiled, as the Empire was beginning to crumble before the First World War, and belief in such figures was dying out. A reporter for *Vanity Fair* noted:

> Mr Tweed, the sculptor, has wrought the eminent buccaneer (Clive) in bronze. When I first noticed the Colonel he was standing on the grass

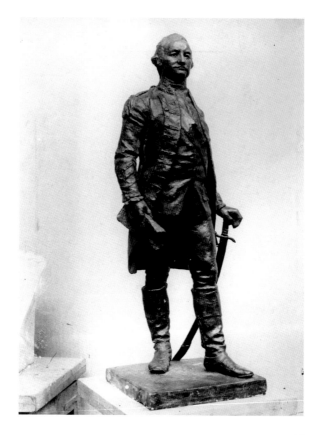

6.7 Lord Clive, *c.*1912, bronze in studio.

plot in front of Gwydyr House wrapped in a tarpaulin – an up-to-date Tweed suit, one may suppose I knew him at once. I knew it was Clive, I could see his boots – high-soled boots accustomed to trampling. Besides, close by was a half-built pedestal with Clive on it in capital letters.[18]

Commissions for single-figure statues did continue for a few years longer; statues to commanders who died during the war were erected and early in 1925 Tweed put in place the final preparations for the unveiling of his statue of Lord Kitchener. Tweed's statue was to be the National Memorial to Kitchener who had commanded the military all over the British Empire, from India to North Africa, and as such the memorial had been given a prestigious site on Horseguard's Parade **(1.4, 6.8)**. A pedestal had been erected on the site in pale stone with the floor around and wall behind covered in the same stone to create a space for the pedestal separated from the rest of the parade ground. One interesting photograph shows a bronze of Captain Cook (probably the cast intended for Hawaii that had been commissioned in 1924) standing on Kitchener's pedestal **(6.9)**. Tweed was probably trying to gauge how the height and shape of a sculpture would look on the pedestal while the Kitchener was being cast in a foundry.

This image suggests Tweed took an active part in revitalising imperialist ideologies of the period. It suggests how reflections of the past were intended

6.8 Lord Kitchener, *c*.1921, clay in studio.

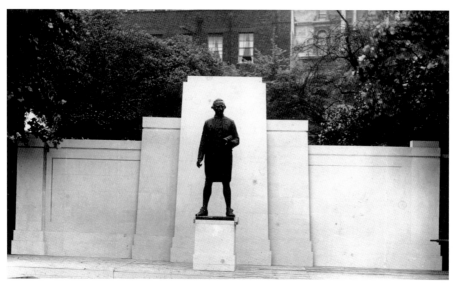

6.9 Statue of Captain Cook on Kitchener pedestal, *c.*1926, bronze and stone.

to inspire and exonerate Edwardian Empire builders. Sadly today these narratives have disappeared from many statues because we simply cannot read their meanings from our modern viewpoint and because the statues themselves have lost their contemporary context. Art historian Sergiusz Michalski explains:

> Bidding for eternal validity, for timeless monumentalization, the statue cannot, alas, deny its all too apparent fashionable trappings. The costume and scenic attributes all echo the most miniscule conventions of their epoch … In lieu of the timeless representation the statue was striving for, one sees instead the signs of time's passage.[19]

Tweed made many war memorials, for military groups and towns, and a few figures of individual commanders who lost their lives in the war, but after Clive he never again made a public monument of a historical figure of the Empire. He continued to be referred to as the 'Empire sculptor' but it was a title that had less meaning the further into the 1920s and '30s the century moved. So while today we may pass these statues and do not have the vocabulary necessary to allow us to decode the layers of meaning within them, they remain illustrations of moments in history, that of the subject's time as well as the time of the statue itself.

7.1 Sketch of soldier, *c*.1918, sketchbook page.

7 War memorials

Tweed as war artist

When the First World War broke out in July 1914 Tweed was 45 and therefore too old to take part in active service. He still wished to do all he could to help the war effort. Like many other Chelsea artists he drilled regularly with the Artists' Rifles. He also volunteered at a military hospital, probably connected to his daughters who were both in the medical services. Tweed also donated works to various exhibitions whose sales were intended to support the war effort usually linked to the Red Cross.[1]

Despite these efforts Tweed wanted to do more, unable to serve his country in a military capacity he began to look for ways to use his artistic skills to aid the war effort. During war, for the first time, the government took a real interest in the possibilities provided by art for propaganda purposes. The late nineteenth century had brought with it technological advances that allowed everyone in the country access to regular news, no previous war in British history had been given such complete coverage. The press provided communities with information and images of current events which meant the war touched every town and village in Britain. The unprecedented numbers of soldiers involved in the conflict meant that there was a far larger audience anxious for news of the war including pictures. The newly formed Ministry of Information recruited war artists for a scheme to record the historic events that were taking place at the frontline in France.[2]

Tweed, by 1916, wanted to be a war artist, although it is unclear exactly how much he understood about the roles of the Ministry of Information and Wellington House. He started by approaching influential contacts and patrons, just as he had developed networks in his earlier professional career. In December 1916 he wrote to the office of Neville Chamberlain, at this time in charge of the Colonial Office, and seems to have asked Chamberlain to put in a word about his ambition.[3] Tweed had completed a bust of Chamberlain's father for Westminster Abbey which had been unveiled earlier

in 1916 and so felt confident in approaching the statesman. Chamberlain, however, seems to have not responded and early in 1917 Tweed persuaded General Aylmer Haldane, whom he knew through being commissioned to produce the statue to Sir John Moore at the Shorncliffe Army Camp in Kent, to speak up for him.

Haldane wrote in May 1917 to John Archer at the Foreign Office to try and find Tweed a position there. Archer responded that while he had openings for men who could operate photographic equipment, 'a sculptor is ill to place in my Department'.[4] Tweed's letters eventually found their way to the Ministry of Information which by then was co-ordinating the employment of artists for official war business. Alfred Yockney, a journalist and art writer in peace time, was in charge of most of the administration and he wrote to Tweed for the first time in April 1918 asking him what his war obligations were as 'it had been suggested that you [Tweed] should be invited to execute a work in marble or bronze.'[5] This work does not seem to have been intended to be a memorial nor was Tweed, at this point, being invited to visit the front. On the 26 April 1918 Yockney wrote to Tweed again, telling him that his letter had been forwarded to the British War Memorials Committee but that the scheme for sculpture had not yet 'matured' and that he would write soon with more details.[6]

The British War Memorials Committee was set up in March 1918 straight after the official constitution of the Ministry of Information; art historian Sue Malvern describes the committee as 'A project closely identified with [Lord] Beaverbrook, it intended to assemble a significant contemporary collection representative of 'the greatest artistic expression of the day' by a wide range of young and modern artists as a memorial to the war.'[7]

From this it can be seen that, although Tweed was being referred to the British War Memorial Committee, the exact notion of a war memorial, as we now conceive of them, had not been worked out. He was being asked to produce a piece of work that could be considered an expression of the war and then kept in remembrance of the war. Meanwhile Tweed continued to campaign to work at either the Colonial or Foreign Office. In May 1918 he received a letter from Sir Harry Batterbee, the private secretary to the Secretary of State for Colonies, to say that Batterbee had spoken of Tweed with Colonel John Buchan at the Ministry of Information. Tweed then wrote to any contact he could glean from his networks of aristocratic and military patrons. Colonel Buchan told Batterbee that the Ministry was very anxious to use Tweed's skills but that, 'it is not easy to use sculpture in propaganda work'.[8] All of his government contacts referred Tweed back to the Ministry of Information.

Tweed, during this period, had also corresponded with General Jan Smuts, who, in 1918, was working as part of Lloyd George's Imperial War Cabinet out of rooms in the Savoy Hotel. Earlier in the war Smuts had been in charge of campaigns from South Africa into German-held East Africa. In August 1917 Tweed received a letter from Joseph Michael Solomon, a pupil of Herbert Baker in South Africa, who wrote to say that he had found a benefactor willing to pay for the bust of General Smuts that they had been discussing and that he should start sittings immediately. The bust was destined for Johannesburg Art Gallery and it seems likely that during the sittings Tweed and Smuts discussed the war, art, and the already significant subject of war memorials.

In July 1918 Smuts received a letter from the mining entrepreneur and De Beers businessman, Ernest Oppenheimer who had heard of Smuts' plan for a South African War Memorial. He gave £2,000 to Smuts to allow him to employ an artist to start making preliminary designs and sketches. Smuts sent Tweed copies of these letters and thanked him for a letter that outlined his proposals for a package of designs and models.[9] On 10 August 1918 Smuts wrote to Tweed saying that he understood that he would soon be able to leave for France and so enclosed a cheque for half of his agreed pay.[10] By the end of August Tweed was attached to the VI Corps under General Aylmer Haldane and installed in a Corps School a little way from the front. He wrote to Smuts discussing the logistics of getting his works cast in plaster in Paris and being allowed access to facilities while not being a serving soldier. These letters show that Tweed was now working independently of any formal British artists' schemes.[11]

In mid-1918 the VI Corps were involved in fighting at the Second Battle of the Somme. At the end of August they attacked German forces at Albert and later in the autumn saw action in the Second Battle of Bapaume, the Battle of the Selle and the Battle of the Sambre before joining other Allied troops to march into the Rhineland after the Armistice.[12] There is an undocumented anecdote that Tweed was the first Allied civilian to enter the Rhineland. In the October Smuts' Assistant Division Commissioner Ernest Lane wrote to him:

> Mind you get up to General Haldane as soon as you can, so as to have an idea of the war of movement and the life and general exaltation amongst the troops who are going up into what they imagine will be an overwhelmingly victorious fight. I have only seen people going up to the Somme where they knew they were going into a real 'blood bath' or else later in the year that they were going into a 'mud bath'. But you are privileged to see the people who are going up and know that their

7.2 Sketch of soldier, *c.*1918, sketchbook page.

casualties are going to be light and their progress most marked, and this really should be the key-note of your work.[13]

Several of Tweed's sketchbooks survive from his time spent at the front. It is unclear exactly what he handed over to Smuts as part of the agreement between them. His sketchbooks are full of quick observational portraits of soldiers. Some are obviously posed while others have been drawn without the sitter's apparent realisation **(7.1-7.3)**. It seems Tweed already had an idea of the types of figures he would be required to portray in sculptural memorials to the war.

Tweed's small bronze, *The Rifleman,*[14] shows the less heroic soldier, not a victorious hero but a grieving man. The soldier stands, head bowed, in front of one of the utilitarian wooden crosses used as grave-markers, in a field of mud. The surface of the bronze has been worked to resemble the slick thickness of the mud and it grasps at the soldier's legs and the bottom of the cross, so much so that the soldier's boots are barely visible. Mud had become something of a symbol of the Allied forces' time in France. It frequently appeared almost as a topic in its own right in coverage of the war

in London-based periodicals. The land on which soldiers fought became a metaphor for the effects of war, the desecration of the land symbolising the loss of life and devastation of war, while the mud swallowed up the dead into its oozing mass. *The Rifleman* is the only war work by Tweed, known today, that shows this kind of mournful detail.[15]

At the beginning of December 1918 the fact that Tweed had decided to stay in Europe for so long after the Armistice was a source of amusement and irritation for those working at Smuts' office in London. Ernest Lane enquired if Tweed would finish his 'holiday' before he had toured half of Germany.[16] Once he returned to London in early 1919 he was sent a cheque for a further £500 for his work at the front. He was then told to exchange ideas with his old friend and adversary the architect Herbert Baker, who since his time working for Cecil Rhodes had continued to design works for the colonies in South Africa and further afield.[17] A committee had been formed in South Africa by Ernest Oppenheimer, the man who had originally put up the money to employ Tweed and send him to the front. Smuts was no longer involved; with the end of the war he was in Europe participating in the negotiations that would result in the Treaty of Versailles. The only other mention of a war memorial in South Africa, amongst the Tweed Archive letters, came in 1922 when he was invited to submit a proposal to the committee for the Cape Town War Memorial (which appears to have been completely separate from the South African War Memorial).[18] Exactly when the commission for a South African War Memorial disappears is uncertain.

7.3 Sketch of soldier, *c.*1918, sketchbook page

His appointment by Smuts was not a guaranteed commission for the memorial but Tweed must have felt that he had a certain vested interest.

Tweed's experience at the front would prove invaluable in his continuing sculptural career in Britain. In the next 24 years he produced nearly 20 war memorials of varying sizes and used his first-hand experience to gain commissions and to produce realistic sculptural portrayals of the soldiers with whom he had marched across France **(7.4)**.

Making war memorials

The end of the First World War is credited with completely changing the traditions and rules of public statuary. It has been considered as the culmination of 'statuemania' and while this is not strictly true, the events of 1914-1918 created an unprecedented need for sculptural memorials. The sudden need to create something that allowed communities to publically acknowledge their gratitude and grief for those who had fought and given their lives meant that the term 'war memorial' encompassed a multitude of objects and ideas, from buildings and sculptures to other forms of memorials such as funds for medical care and education. The different organisations that erected memorials had varying ideas about what they wanted them to represent; however most included some form of sculptural or architectural object. Catherine Moriarty has argued that there was a need for a sense of neutrality in war memorials which allowed viewers to project their own stories of grief onto the sculpture, allowing a mother, for example, to recognise her dead son in the bronze depiction of a soldier.[19]

It should be noted that the meanings of memorials from the First World War, have changed over time. In the years after 1945 many became

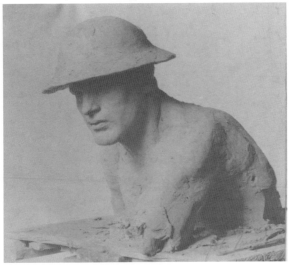

7.4 Bust of soldier, *c.*1920, clay in studio.

memorials to both the fallen of the First and Second World Wars. More recently they have been reinscribed again, both literally and metaphorically to memorialise the fallen in modern conflicts in the Falklands, Iraq and Afghanistan. The meanings of First World War memorials continue to be reconsidered by successive generations both as memorials to historical conflicts but also as vehicles for feelings about contemporary wars. As a result many have evolved into artworks quite different from the ones envisioned by the artists and memorial committees of the early 1920s.

The building of First World War memorials was a nationwide, all-encompassing activity; every community felt the need to have one. Often an area would have a large municipal war memorial, while schools and churches and other organisations within that area also built their own smaller memorials. In a sense there was a multi-layering of memorials which made sure none of the fallen were forgotten and that people could remember and mourn in different ways at different places, in their parish church, their local town, local regiment, regionally and nationally. Tweed was the author of many memorials of varying size and importance. He created the national memorial to Lord Kitchener, the memorial for the House of Lords, a town memorial in Barnsley, several regimental memorials as well as producing much smaller works for villages, hospitals and schools.

In a continuation of the Victorian and Edwardian idea of memorial statuary many war memorials were figurative. Tweed and other sculptors of the period moved from working on images of important, individual men at the top of the social hierarchy to depicting the 'everyman'; the common soldiers who were considered, after the war, to have been the most important participants who needed to be commemorated. The First World War can be considered as performing a democratic levelling of the sculptural object.

The task of making war memorials required people to find a way to best represent the fallen and the sacrifice that they had given. Memorials had to exude a sense of propriety and to promote a specific idea of the dead and of the soldier. There were many aspects to be considered: the depiction of victory, the depiction of violence, and producing images of soldiers that were respectful, and in keeping with the sense of mourning. The specifications of these boundaries were not explicitly addressed but were broadly consensual across all the organisations that raised memorials to their dead and missing. Alex King discusses the image of the soldier in relation to one of Tweed's memorials for the King's Royal Rifle Corps at Winchester:

> In general, the achievement of the dead was represented as an ethical triumph over evil rather than a military triumph over other people. The soldierly nature of their triumph was only ambiguously acknowledged.

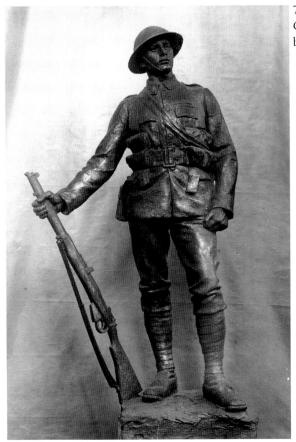

7.5 King's Royal Rifle Corps Memorial, *c*.1918-22, bronze in studio.

Artists generally avoided images which might suggest violence. The military figures on Keighley war memorial, unveiled in 1924, were praised for being 'so balanced in poise as to give an impression of alertness and vigour, yet without any hint of aggressive force'. The same effect may have been intended in John Tweed's figure for the memorial to the King's Royal Rifle Corps in Winchester, 1921.[20]

The figure of the soldier at Winchester stands holding his rifle loosely in his right hand, the butt rests on the floor while the soldier stands at ease and gazes into the distance **(7.5)**. The pose gives the sense that the soldier is remembering, is grieving along with the audience but he remains able to react, to respond to any danger and so not only reflects the solemnity of the memorial but also the abilities of those who fought. Whether the figure is a returning soldier or a dead soldier is ambiguous and allows the viewer to interpret the memorial in their own way with regard for the circumstances of individual losses **(7.6)**.

Like many other professional older sculptors in the early twentieth

century, Tweed was not unused to producing war memorials. One of the first sculptural competitions he entered was for a memorial to the Cameronian Regiment to celebrate their bicentenary in 1889 and to remember the fallen of those 200 years. The Second Boer War from 1899 to 1902 required the voluntary subscription of civilians in order to boost army numbers and resulted in a large number of British casualties. The resulting widespread sense of sacrifice was commemorated with sculptural memorials for the first time. Tweed made several relief tablets to individual soldiers as well as an organisational memorial for those who had served from St Mary's Hospital in north London.

Tweed's designs for war memorials were successful. He won the majority of the competitions he entered, or was chosen from a short list of sculptors by the various commissioning committees. On occasion, he was helped by those who sat on the committees who knew and admired his work. There is, however, a consensus among historians that there was an approved style, a sense of propriety that created First World War memorials as a certain type. What is unclear and still being discussed is how sinister this style was, who orchestrated its success if indeed it was not an organic movement.

7.6 Statuette of KRRC Memorial, c.1922, bronze in studio.

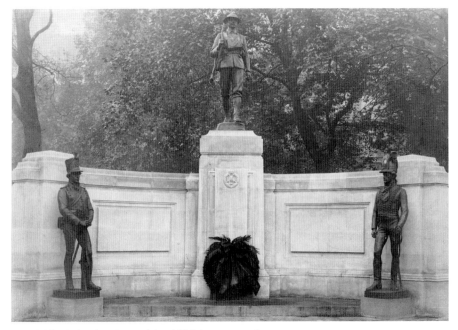

7.7 Rifle Brigade Memorial, *c*.1925, bronze and stone.

Artists, quite often, had very little autonomy over the formal elements of the memorial. For example the Rifle Brigade Memorial committee specifically stated in their contract with Tweed that they wished for:

> A memorial consisting of three bronze statues representing,
> a) A Rifleman in the war kit of 1918
> b) An Officer in the uniform of 1809
> c) A Rifleman in the uniform of the same date to be placed
> on a stone pedestal and screen according to the drawings
> submitted.[21] **(7.7)**

While Tweed had submitted a design based around the requested formal elements the idea had not begun with him. In a letter dated 4 July 1919 from Colonel Willoughby Verner wrote:

> I send you a very rough idea of what is in my brain … an officer in a helmet (Copenhagen 1801) and the other a Rifleman in his shako (Peninsula – Waterloo, 1800-1815) to include the whole foundation of our 'espirit-de-corps', around the pedestal would be the words 'Copenhagen – Peninsula – Waterloo – Crimea' all European battles where no other British Rifleman were employed![22]

Geoff Archer has discussed how a fellow sculptor, Goscombe John, created a similar monument which involved depicting combatants from past conflicts:

> The combination of contemporary and historical figures was a favourite approach of Goscombe John and both here and elsewhere the uniform of the historical figure relates to the date of the regiment's formation, thereby suggesting a continuation of the regiment's honourable tradition.[23]

He goes on to discuss Tweed's memorial for the Rifle Brigade and how the flanking soldiers in historical dress relate to the service seen by the Brigade during the Peninsula War.[24] This interest in promoting a history of soldiers tends only to be seen in memorials raised by military organisations, the same organisations that were more concerned with the figures being perceived as respectful but appearing active. The contemporary First World War figure on the *Rifle Brigade Memorial* strides forward with his rifle slung over his shoulder while the two historical soldiers stand more at ease. Despite the fact that these figures were made for a specific military memorial the contemporary soldier from the *Rifle Brigade Memorial* was used elsewhere. Tweed produced two more memorials based on the figure, one for the Welsh village of Bodfari, where a much smaller bronze stands on small pedestal in the village churchyard and, according to Geoff Archer, also for the Scottish village of East Wemyss.[25]

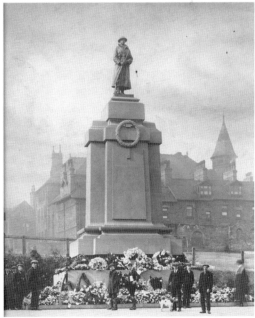

7.8 Barnsley Memorial, *c*.1925, bronze and stone.

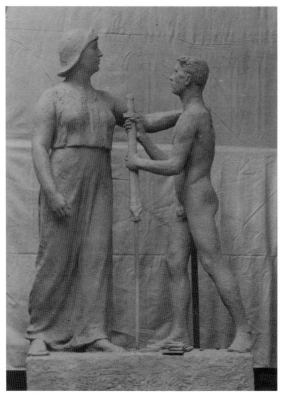

7.9 House of Lords Memorial, 1918-32, clay in studio.

The impact of the war on sculpture as a profession was profound, from creating a huge amount of work after a period of severe depression in the art world to allowing artists working in various styles to produce large scale public works. Art historians have credited the memorials of the First World War with being both the last large-scale erection of Victorian figurative sculpture but also with providing an opportunity that advertised the work of more 'modern' artists. Sculpture like Tweed's has been compared to works like Jagger's *Royal Artillery Memorial* and found to be lacking innovation or considered stylistically dull. This is an unfair response that has had a negative effect on the reputations of many artists and a whole style and period of British sculpture. Most poignantly his First World War memorials are works that are still very much appreciated today. They still provide the visual focus of memorial services, rituals and for the memory of many more participants in many other conflicts. Tweed spent the rest of his career from 1918 until 1933 working upon numerous commissions for war memorials **(7.8, 7.9)**. His reputation for producing public statues and memorials grew and was often favourably commented upon by the media but these larger works overshadowed, to some extent, Tweed's passion for smaller imaginative works of sculpture.

8 Ideal works

Throughout his career Tweed worked to produce sculptures that impressed his commissioning patrons but he also made works that were solely the product of his artistic imagination. He continued, despite his heavy workload, to experiment with sculpture. These personal sculptures, known as ideal works, usually took the human figure as their subject and were advertisements of Tweed's artistic skills, style and his personal views of what sculpture should be **(8.1)**. Their exhibition at places like the Royal Academy was paramount for creating and maintaining an artistic reputation in the hugely competitive sculptural scene of the early twentieth century.

Tweed did not understand his work as 'modern' and towards the end of his career would have been insulted to hear his work described as such. His lack of interest in work that was considered modern and new in the 1920s bordered on disgust. He told a reporter from the *Evening News* in 1925 at the British Empire Exhibition: 'All these -isms are summed up by one all embracing '-ism' and that is … sensationalism'[1] In his view the sculpture of Cubism and other modern movements placed too much emphasis on form over a sense of beauty and also disregarded nature, the two concepts that Tweed considered paramount to successful sculpture. In a sense he is right. Many artists in the 1920s and '30s were working in reaction to what they saw as the unthinking, sugary beauty of the Victorian period. The success of these artists and their sculpture has allowed their views to become the standard way of considering earlier sculpture, as reactionary, conservative, uninteresting and uninspiring. Tweed's inability to even attempt to engage with modern art has led to him being simply included in the supposed homogeneity of reactionary, academic Victorian sculpture.

Tweed, in fact, was never afraid to stand on his own away from prevailing trends and fashions, as Gervase Beckett described when talking about his career in 1934:

> Latter days found him at variance in many ways with the present taste in
> Art, and Sculpture perhaps in particular. He refused deliberately to accept

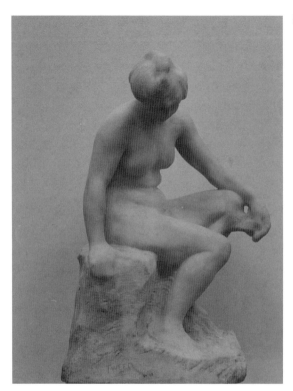

8.1 *Carmen, c.*1903, marble.

the creed that all the great traditions, all the established and historic canons of beauty were to be whistled down the wind and only the flat-sided contortionists of the passing present to be welcomed as the whole truth, after centuries of search, for no better reason than that they are modern and monstrous. For him the Gods were the Greeks and great Italians.[2]

Tweed purposefully affiliated his art with the work of three different sculptural ideas, those of Rodin, the New Sculpture and Ancient Greek sculpture. Perhaps surprisingly, given his connections and relationship with Rodin his ideal works are not always obviously Rodinesque in style or character. Tweed did not simply repeat or copy styles and ideas made by artists he admired, he worked to blend influences in order to produce sculptures that were, in his eyes the epitome of beauty.

Beauty was a key term for Tweed who felt that artists should strive to create works that were primarily beautiful; like Rodin, he felt that the only way beauty could be achieved was through the study of nature. A primary inspiration for both Rodin and Tweed was Ancient Greek sculpture and in some ways this placed Tweed within the critical discussions of the London sculptural world. Classicism was seen as a positive inspiration; many critics,

uncomfortable with the progressive elements of modern foreign sculpture, saw classicism as a safe influence which would stem the tide of modernist tendencies.

It is difficult to clarify what Tweed thought the art of the Ancient Greeks stood for and even more difficult to know what he felt his art took from Ancient Greece and how it illustrated this. He seems to have seen Ancient Greek sculpture not just as the epitome of the idea of beauty in art but also truth. In their reliance on proportion and nature Ancient Greek sculptors adhered to the doctrine of realism that both Rodin and Tweed believed was the only way to successfully depict beauty. His idea of beauty was not always an idealised beauty nor was it a completely realistic beauty. In fact Tweed

8.2 *Drucilla, c.*1903, marble.

viewed beauty as an abstract and complicated concept which was not always attainable but which he strove for in all his works. This is not to say that he was trying to imitate the Greeks. It is more complex than that; instead he is trying to produce a similar beauty, a similar aesthetic but still quite set in his own time, employing contemporary techniques and life models **(8.2)**.

Tweed's notions of beauty and nature are confusing and his discussions of his art lack definition. In a lecture given to the Royal Institution in 1929 he admitted his difficulty in defining his ideas:

> It is with hesitation that I venture to speak on the silent art of sculpture, for though it has been my daily work and study, and has given me much joy in pursuing it, I need not add it has given me much misery, for no artist ever realised his dream of the finished work. Yet I find it very hard to talk about – to find the words that will convey what I want to express in another medium. You can discern but not describe.[3]

He did not define his own style and he never clearly explained what it was that he was aiming to create through his sculpture – simply that he worked from nature to produce beauty. Tweed's lack of voice and articulation of his ideas has meant that he has been overlooked by art history which has focused its attention on artists with a clearer sense of their own style. His idea of beauty was more complicated than any simple Victorian idealisation and to a certain extent was also working in reaction to the saccharine beauty of mid-nineteenth century sculpture:

> Tweed was tired of the almost universal gracefulness, sometimes degenerating into prettiness and pettiness, that he found in British sculpture, and set himself to put strength and vigour in its place, and he succeeded without overstepping the mark. His work is refreshing, for it indicates this new outlook on the art, but he has been successful in avoiding extremes, and his statues and other works prove how valuable it is to be true to nature if you want to be impressive.[4]

Both Rodin and the New Sculpture sculptors took ideas and influence from ancient classical sculpture but in different ways. Both took the Greek classical statue, firstly the male nude and later on the female, and tried to produce a new understanding of sculpture itself. Frederick Leighton used the look and movement of the Greek classical figures as his inspiration for the New Sculpture, whereas Rodin was interested in mastering their techniques and using those techniques to create a form of sculptural representation. Tweed himself was exposed to Greek sculpture throughout his education in Glasgow, London and Paris. Later in his career he spent much time studying

the Parthenon sculptures at the British Museum, producing sketches of the triglyphs; in particular those which depicted the battle between the centaurs and Lapiths.[5]

Connected to this was Tweed's interest in Renaissance sculpture, his second major influence. The Italian Renaissance was a reference used by many late nineteenth-century sculptors including Rodin and the New Sculpture sculptors. Rodin was famously influenced by Michelangelo[6] and interestingly both the influences can be seen in Tweed's male nudes. The muscular and contorted idealised figures of Rodin drew comparisons with Michelangelo. Octave Mirbeau commented on *Porte d'Enfer* that, 'one has to go back to Michelangelo to find anything as noble beautiful and magnificent in art'.[7] Similar comparisons were made about the New Sculpture artist

8.3 *Luigi*, date unknown after 1905, bronze in studio.

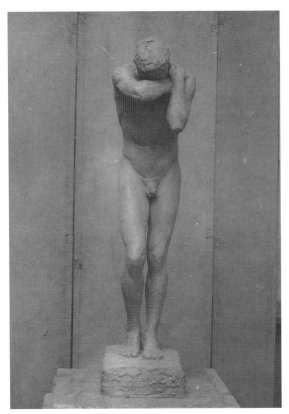

8.4 *Defeat, c.*1932, clay in studio.

Alfred Gilbert and the influence of Donatello. Some of Gilbert's ideal works such as *Perseus Arming* were centred around a sense of androgyny, grace and delicacy, quite removed from the muscularity of Michelangelo. The style of Tweed's ideal works is a fusion of Rodin's and the New Sculpture's ideas and techniques. His male nudes, *Luigi* and *Defeat*[8] provide two of the best examples of this.

Luigi **and** *Defeat*

Luigi is a bronze standing male nude, a statuette made to be about a quarter of life size **(8.3)**. He stands with clenched fists at either side of his body and stares at the ground, he does not interact with the viewer; because of this the viewer's attention is not drawn to his face but to his finely depicted muscular body which stands in a twisted contrapposto position. The pose and representation of an idealised muscular body is very reminiscent of Michelangelo's *David*, a work he would have seen on a trip to Italy in 1904[9] with Gervase Beckett.[10] It is also possible to see in Tweed's rendering of the overlarge hands and feet and the inwardness of the pose hints of Rodin's influence.

Early New Sculpture ideal works from the 1880s such as Thornycroft's *The Sluggard* or Gilbert's *Perseus Arming* used a kind of Ancient Greek stereotype in face and hair, to suggest an entirely idealised type as opposed to an individual. Idealised sculptures that resembled the models that had sat for them developed from later New Sculpture sculptor's interest in realism and naturalism. It was not always met with enthusiasm. Critics often felt that younger sculptors went too far with their search for naturalism; Edmund Gosse felt that Edward Onslow Ford's ideal figure *Peace* was, 'wanting in the highest element of all such work – distinction. The feet and ankles of this 'Peace' are so thick and clumsy as to be positively grotesque; and the face,

8.5 Andrieu d'Andres from *Les Bourgeois des Calais,* Westminster, Auguste Rodin, bronze, cast from 1908.

beautifully executed, is just the stupid, vacant face of the professional sitter'.[11] *Luigi* also seems to retain elements of the model's individuality; it is entirely possible, although there is no documentary evidence for it, that Luigi was the model's name. Other ideal works with simple names have been linked to the models that sat for them: these include sculptures of Tweed's ex-fiancée Hetty Pettigrew and the Italian Orazio Cervi.

Defeat is a life-size male nude who stands with all his weight on left leg while his right is light and bent at the knee. His head is clasped in his arms, in a pose of despair **(8.4)**. Tweed based this work on a losing rower at Henley.[12] His son Rathlin rowed for Magdalen College, Oxford, during the early 1920s.[13] The figure is much more slender than *Luigi* and the pose has far more curves compared to the linear stature of *Luigi*. It shows the influence of Donatello and the more delicate sculptures of artists such as Alfred Gilbert in works such as *Icarus* (1884). The features of the figure are hidden by the pose but are also more 'smoothed' out than in *Luigi*. There is less sense of recognising an individual in this work than in *Luigi*. Lendal Tweed calls this work 'his finest, idealistic piece'[14] and describes it further:

> *Defeat* is a full-scale figure of an athletic youth, the muscles taut across his shoulders, but the head bowed on the flexed arms in the agony of unsuccessful effort. The modelling, and to some extent the pose, recall Rodin's L'Age d'Airain.[15]

Although *Defeat* is similar to *L'Age d'Airain* (The Age of Bronze) in stance and in the depiction of a more slender body type, the pose of *Defeat* more closely resembles that of Andrieu d'Andres in *Les Bourgeois de Calais,* the burgher who holds his head in despair as they walk to their deaths **(8.5)**. Both the Rodin works have connections to the idea of defeat, while *Les Bourgeois de Calais* has the subject as an obvious subtext, *L'Age d'Airain* has been connected to France's defeat in the Franco-Prussian war in 1871. *Defeat* therefore picks up on a tradition of depiction that again pays homage to Rodin as well as absorbing the stylistic influence of the New Sculpture.

Latona

Both *Luigi* and *Defeat* are bronze which is the most usual medium for ideal sculpture as it is relatively light and so allows the sculptor more freedom when he constructs poses. However, it is a marble that can be considered to be Tweed's most successful ideal sculpture, *Latona*, his most exhibited and widely discussed work **(1.2, 8.6)**. In an article in *The Standard* in 1929, near the end of Tweed's career, the reporter dwelled on *Latona* who was, as he saw in his studio, always kept under a cloth away from the gazes of the male

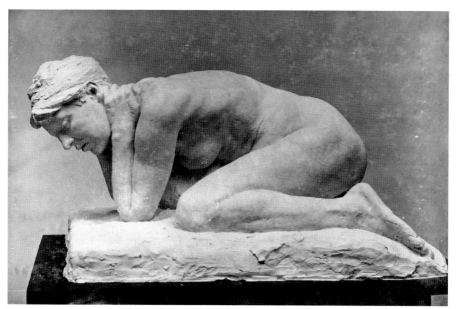

8.6 *Latona*, 1905, clay in studio.

heroes he usually portrayed. Tweed told him that he could not sell the work because Rodin thought she was his best work. He discussed how he showed it both at the RA in London in 1912 and at the Salon in Paris, after which he was invited to join the Societe des Beaux Arts. Tweed also mentioned that there had been an agreement to sell it to the French nation but he had decided against it.[16] After his death in 1933, *Latona* was given to the French nation by Mrs Tweed. At that point it was given to the Musée Luxembourg and is now in the Musée d'Orsay in Paris.

Tweed seized upon the unusual pose, sketching an informal moment in his studio when a model curled up on the floor to read a magazine between sittings. *Latona* was not greeted with interest when it was first exhibited in London in 1906, Tweed's crouching nude was criticised in *The Builder* in a review of the New Gallery exhibition:

> Mr. Tweed's 'Latona' (531) is a well-modelled nude, though why the mother of Diana, should be shown in this ungainly crouching attitude is not very obvious; it looks rather like a classical title given to what was merely a life study.[17]

However, as the twentieth century continued her reputation grew. In 1912 *Latona* was well received both at the RA and the Salon. By 1933 and Tweed's solo retrospective at the Knoedler Galleries, she was praised by

Kineton Parkes as his best work: 'Latona has not been fabricated recently but it remains the artist's most important ideal work. It is eloquent in form – expression and full of static grace.'[18]

Latona is the Roman Latinised version of Leto who, in Greek mythology, was the mother, by Zeus, of Apollo and Artemis, and who was a victim of Hera's jealousy. She is occasionally considered to be the goddess of night: she had to give birth in the shadow of a tidal wave sent by Zeus.[19]

Tweed's depiction of *Latona* is of a nude woman kneeling almost on all fours, with her hands around her neck and her legs folded underneath her. She was generally described by the press, when she was exhibited at the RA in 1912, as a reading figure although she is not shown with a book and instead appears to stare intently at the floor in front of her. Her body has been represented with a strong sense of naturalism to include the slight folds of skin on her stomach and the tautening of the muscles in her upper arm as she places her weight on to them. Her hair is short and appears curled; *Latona*, as with *Luigi*, appears to resemble more a nineteenth-century artist's model than the idealised Greek goddess. In fact the title '*Latona*' is confusing, particularly when we consider that there is no obvious relationship between the title and the work of sculpture. It may simply be that as Tweed and Rodin felt this work was particularly good and that he wished to refer to the Ancient Greeks that he and Rodin admired so much and in doing so link his art with that of classical Greece.

At first glance *Latona's* naturalism would appear indebted to the New Sculpture. However she has none of the props of a New Sculpture female nude and she has been given a title that does not directly reflect the subject. Under different circumstances, such a title would have led to a sculpture being produced that somehow illustrated the life or an event in the life of the goddess. Tweed has made her isolated and unencumbered by allegorical details. In fact if she is reading, this seems to be an odd thing for a goddess to be doing. Again we are aware in one of Tweed's ideal works the model who held this difficult pose in his studio, was not a goddess but a mortal nineteenth-century woman. The overt use of realism is due to Rodin's insistence of the study of nature in the production of beauty. A critic for *The Times* similarly discusses this idea in sculpture at the 1912 Royal Academy exhibition:

> it may be portraiture of the body as well as of the face – or when, like poetry or music, it is a means of expressing some emotional conception. A great deal of the sculpture of the Academy is neither, but a mere imitation of the human body with all individuality eliminated, so that it may not be obviously incongruous with some vaguely romantic

title. Again, our municipal passion for effigies often imposes upon the sculptor an impossible task. He has to make a statue of some one long dead, in whom he is not at all interested, and of whom he has no more knowledge, perhaps, than can be got from a dull portrait. His only chance in that case is to produce a figure in some way expressive of the virtues of his subject and forgo portraiture altogether.[20]

The critic mentions *Latona* specifically, 'Mr Tweed's 'Latona' is an able work in the manner of Rodin, but it has not the air of reality which Rodin gives to his finest work.'[21] This is a just comparison but what the critic does not say in his one short sentence is that Tweed has given him exactly what he asked for in his earlier passage on sculpture. His works often show a mixing of the styles of the New Sculpture and of Rodin but they do also exemplify Tweed's greatest talent – his ability to produce sculptural portraits. In nearly every ideal work he produces there is a trace of the original model who posed for the work whether he intended it or not.

Latona also illustrates Tweed's interest in a depicting a certain shape of woman; nearly all of his female nudes are not the consumptive figures that had so intrigued artists of the late nineteenth century. His women have a weight and a chunkiness to them. A scrapbook in the Tweed Archive holds several pages of art postcards which show female figures by artists such as Gauguin, Maillol and Degas whose poses and body type are similar to many of his female nudes. They all have an awkwardness about them, a sense of self-consciousness that stems from the realism of their bodies. Tweed continued to explore the female form and the poses of his later ideal works are even more simplified, less graceful and slightly uncomfortable to look at. With *Latona* even his choice of medium creates a conflict between the ugly pose and the smooth, skin-like finish of the marble; it is interesting to consider how different she would seem had she been produced in bronze.

Tweed's blending of the New Sculpture and Rodin makes his sculpture an interesting variation on the two dominant styles of his period. It was not recognised during his career and has not been recognised since. Tweed's inability to produce a large and consistent body of ideal work in his own style has blocked his positioning in the sculptural theory and history of his period but does give a sense of his ability to produce a range of work and his diverse and deep thinking about the sculptural object.

9.1 Tweed Memorial Exhibition, Imperial Institute, 1934.

9 Exhibiting for the last time: 1933 and 1934

In November 1933 John Tweed died in a nursing home in Fulham, the official cause of death was pneumonia causing respiratory collapse but many obituaries also reported that he had died from exhaustion. The last fifteen years of his career were his most productive and the scale of the works that he completed only grew in size and prestige. Tweed was pictured in *The Times* in January 1933 working on a bust of Sir John Eliot, the opposition leader during the reign of Charles I, which had been commissioned for the House of Commons.[1] Later in 1933 he had supervised the hang of his first solo exhibition at Knoedler's Gallery in London. He had attended the opening view and received some of the admiring praise for his work before he became too ill to continue to work. *The Times* obituary called him, 'one of those sculptors, who, without attaining Academic rank, are entrusted with commissions of first-rate importance, and occupy an equal place in the public estimation with their Academic brethren.'[2]

After Tweed's death it was announced that a committee, including his eldest daughter Ailsa, as well as his friends the politician Sir Gervase Beckett, the sculptor Frank Dobson and the curator of the V&A, Eric Maclagen, would be organising a memorial exhibition for the summer of the following year. The Imperial Institute in South Kensington was very quickly offered as an appropriate venue. The imposing brick Gothic building was finished in 1893 and was designed to house a centre for research into promoting and improving trade around the British Empire. It also contained the Imperial War Museum from 1924 until 1936 and the separate art gallery.[3] Tweed had only a few years before donated two plasters of his statues of *Captain Cook* and *Lord Clive* to the Institute.[4]

The high-ceilinged rooms of the Institute were top-lit by natural light and so made an excellent location for the exhibition, the space able to cope with full-scale casts of public monuments as well as smaller portrait busts and

ideal works **(9.1, 9.2)**. At one end of the room was hung a patinated plaster of one of the reliefs that Tweed produced for the *Allan Wilson Memorial*. This was flanked by full-size casts of *Captain Cook* and the striding soldier that surmounted the *Rifle Brigade Memorial* in Grosvenor Square. The other end included a full-size cast of Cecil Rhodes along with two of Tweed's later ideal bronzes of the male nude *Defeat* and *Luigi*. The centre of the room was dominated by the large marble of *Latona,* while along the walls were lined up numerous portrait busts interspersed with smaller examples of his ideal works in bronze, marble and plaster. The venue also suited his occasional description as the 'Empire Sculptor' and portraits of Rhodes, Cook, Clive, Dr Jameson, Chief Khama, Lord Curzon and Lord Ronaldshay cemented this idea in the view of the popular press. However, a reporter for the *Bulwayo Chronicle* (home to one of Tweed's public statues of Cecil Rhodes) saw more in his portraits of 'Empire builders' and commented that,

> A cast of the colossal Salisbury statue of Cecil Rhodes which towers over the statues of other Empire builders in the exhibition prevents one from realising this fact (that Tweed preferred art to action) at the first glance, but a closer examination of the works will confirm it. Tweed's chosen world is the world of dreams and thought rather than the world of action. His most successful portraits of empire builders are those which express some sort of spiritual emotion. When his sitters were strong, silent men, without sweetness or light, he seems to have lost all interest in them.[5]

9.2 Tweed Memorial Exhibition, Imperial Institute, 1934.

The exhibition was well attended and the Press reported attendance lists of artists, politicians and members of the aristocracy. It was opened by Princess Alice of Athalone whom Tweed had met aboard ship *en route* to South Africa in 1930. *The Times* critic praised the exhibition for enhancing Tweed's reputation and commended his talent as a portrait artist, indeed it was suggested that the number of 'famous' visitors to the exhibition were visiting either to view their own portrait or that of a friend or relative. *The Times* critic however does praise Tweed's oeuvre overall:

> Consistency, indeed, is one of the effects of the exhibition, in spite of the differences in scale and material, and is a consistency of feeling as well as of execution. The exhibition hangs together remarkably well as the expression of a single personality. Speaking, generally Mr. Tweed's modelled work for bronze casting was superior to his carved wood, the most attractive piece in marble here being the head of 'Ailsa Tweed,' which is treated on 'impressionistic' principles, with slightly blurred eyes and mouth.[6]

John Tweed practised sculpture during the arts' most popular and most prolific period; working right at the centre of the London art world he made an incredibly successful career for himself. Never admitted to the Royal Academy, although he was nominated fourteen times, he worked as both a respected practitioner and as an outsider. He never compromised on his views or his ideas about sculpture and its place in the art world. He grew from a young artist, viewed suspiciously for his love of French art into a successful, professional sculptor who by the end of his career was unable to reconcile himself to the new, harsh modern forms emerging in the 1930s. His career was an accomplished one and Tweed, while able to produce large scale public statues for specific patrons, was also a determined artistic sculptor who experimented and worked to further ideas and aesthetics of British sculpture.

Many press reviewers of Tweed's memorial exhibition felt certain that his art would endure. In 1934, despite the First World War and the possibility of the Second, it seemed unlikely that the public statues of men of the Empire and the portrait busts of the aristocracy would lose their importance or their meaning. In the mid-twentieth century the perceived need to completely reject Victorian values, political, social and cultural, led to a disregard for the art of the time and for the history it represented. More recently the transformative nature of this period of history has led to renewed interest as scholars seek to understand how this time has shaped the world today. In terms of art this has included an interest in the birth of the art and

ideas surrounding Modernism. It has been popular to view the beginning of modern art as a rupture which had no relevance to the period that preceded its appearance. More recently the varied narratives that make up this period of art have been reconsidered and given greater importance in their relevance to our lives today. This is where Tweed has been left out. His relevance to the history of art and to art today has been seen to be negligible. Studying Tweed not only illuminates the practice of sculpture at the turn of the twentieth century, it also reveals relationships and collaborations amongst other artists and gives a greater understanding of the London art scene. Tweed's interesting and successful career rewards investigation and this book is hopefully the beginning of a broader reconsideration of his work.

Notes

Abbreviations

HMI Henry Moore Institute, Leeds.

JT John Tweed.

TA Tweed Archive, Reading Museum, Reading.

UP University Press.

1: Introduction

1. Parkes, Kineton, 1921, *Sculpture of To-day*, Chapman & Hall, London, 137.
2. Sheridan, Clare, 1929, *Nude* Veritas, Butterworth, London, 12.

2: Beginnings of a career

1. Tweed, Lendal, 1936, *John Tweed, Sculptor: A Memoir*, Lovat & Dickson, London, 15.
2. JT, 1888, letter to Hamo Thornycroft, Thornycroft Archive, HMI.
3. JT, 17 Feb. 1888, diary, TA.
4. JT, Mar. 1889, diary, TA.
5. 6 Dec. 1888, governors' minutes, Glasgow School of Art, Archives of School of Art, Glasgow.
6. JT, 1888, diary, TA.
7. Ibid.
8. Ibid.
9. McKenzie, Ray, 2002, *Public Sculpture of Glasgow*, Liverpool UP, Liverpool, 149, 156.
10. Allan, Willie, 29 Aug. 1887, letter to JT, TA.
11. Armstrong, William, 14 Jul. 1889, letter to JT, TA.
12. Ibid.
13. Armstrong, William, 28 Feb. 1890, letter to JT, TA.
14. Thornycroft. Hamo, 6 Jul. 1888, letter to JT, TA.
15. Cameronian Memorial Committee, 29 May 1889, letter to JT, TA.
16. Tweed, L., [n. 1], 30–5.
17. JT, 1890, diary, TA.
18. Manning, Elfrida, 1982, *Marble and Bronze: The Art and Life of Hamo Thornycroft*, Trefoil, London, 19–90.
19. Ibid., 196–212.
20. Thornycroft, Hamo, 1889, journal entries for Apr., Thornycroft Archive, HMI, 34–6.
21. Manning [n. 18], 117.
22. Beattie, Susan, 1983, *The New Sculpture*, Yale UP, New Haven & London, 69.
23. Thornycroft, Hamo, Nov. 1890, note in journal (J5), Thornycroft Archive, HMI, Leeds, 120r.

24. Upton, Helen, 1993, 'Hamo Thornycroft and his Models', in *The Alliance of Sculpture and Architecture: Hamo Thornycroft, John Belcher and the Institute of Chartered Accountants Building*, Henry Moore Centre for the Study of Sculpture, Leeds, 29.
25. Thornycroft. Hamo, 1 Jun. 1891, note in journal (J6), Thornycroft Archive, HMI, 46v.
26. Manning [n. 18], 83.
27. Warner, Rose, 1947. 'Memories of Philip Wilson Steer', in Laughton, Bruce, 1971, *Philip Wilson Steer 1860-1942*, Clarendon Press, Oxford, 116.
28. Blow, Sydney, 1958. *Through Stage Doors or Memories of Two in the Theatre*, Chambers, London, 60.

3: Rodin

1. Tweed, Lendal, 1936, *John Tweed, Sculptor: A Memoir*, Lovat & Dickson, London, 64.
2. Elsen, Albert E., (ed.), 2003. *Rodin's Art: the Rodin Collection of the Iris & B. Gerald Cantor Center for Visual Arts at Stanford University*, Oxford UP, Oxford & USA, 13.
3. JT, 1898, letter to Rodin, TA.
4. Whose younger brother Gervase was the editor and owner of the *Saturday Review*.
5. JT, 15 Apr. 1902, letter to Rodin, Musée Rodin, Paris.
6. Quoted in Grunfeld, Frederic, 1987, *Rodin: A Biography*, Hutchinson, London, 434.
7. 1903, minute book of the Committee of the International Society, Tate Archives, London.
8. Rodin, 1905, letter to JT, TA.
9. Ibid.
10. Ibid.
11. Quoted in Newton, Joy, 1994, 'Rodin is a British Institution', in *The Burlington Magazine*, 136, 824.
12. Mitchell, Claudine, 2004. 'The Gift to the British Nation: Rodin at the V&A', in *Rodin: The Zola of Sculpture*, Mitchell, C., (ed.), Ashgate, Aldershot, 186-7.
13. Rodin, 1914, letter to JT, TA.
14. Ibid.
15. Ibid.,
16. Ibid.
17. Maclagen, Eric, 1914, letter to Sir Cecil Smith, V&A Archive, London.
18. Smith, Cecil, 1914, letter to Eric Maclagen, V&A Archive, London.
19. Mitchell [n. 12], 188.
20. Ibid., 187-8.
21. Ibid., 189.
22. Newton [n. 11], 828.
23. Rodin, 1914, letter to Cecil Smith, V&A Archive, London.
24. Ibid.
25. Mitchell [n. 12], 183.
26. Rodin, 1906, letter to Edith Tweed, TA.

4: Portraying the Empire

1. Strangman, Edward, 1901, receipt for sales of Rhodes statuettes, TA.
2. Wyndham, Madeline, Jul. 1902, letter to JT, TA.
3. Compton, Roy, 1898, 'The Rhodesian Sculptor', in *The Idler*, London, 403.

4. Blow, Detmar, 3 Aug. 1897, letter to JT, TA.
5. Lambert, Angela, 1984, *Unquiet Souls : The Indian Summer of the British Aristocracy*, Macmillan, London, 79-81.
6. Tennant, Pamela, May 1898, letter to JT, TA.
7. Tennant, Pamela, 24 Aug. 1899, letter to JT, TA.
8. Tennant, Edward, 10 Dec. 1899, letter to JT, TA.
9. JT, 28 Dec. 1899, letter to Edward Tennant, TA.
10. Tennant, Edward, 24 Jul, 1904, letter to JT, TA.
11. Tennant, Edward, 28 Jul. 1904, letter to JT, TA.
12. 8 May 1909, *The Academy*.
13. Wyndham, George, 21 Feb. 1909, letter to JT, TA.
14. Lygon, William, 5 Aug. 1923, letter to JT, TA.
15. Wyndham, George, 21 Feb. 1909, letter to JT, TA.

5: Mediating Cecil Rhodes: Edwin Lutyens and Arthur Collie

1. Ridley, Jane, 2003, *Edwin Lutyens: His Life, His Wife and His Work*, Pimlico, London, 12-14.
2. Ibid., 52-3.
3. Ibid., 63.
4. Masse, H.J., 1935, *The Art-Workers Guild 1884-1934*, Shakespeare Head, Oxford, 104.
5. Ibid., 91-2.
6. Jones, Claire, 2011, 'Edmund Gosse and the New Sculpture', paper given at *The British Sculpture: Reviewing the Persistence of an Idea*, HMI.
7. Gosse, Edmund, 1895, 'The Place of Sculpture in Daily Life: II. Sculpture in the House', in *The Magazine of Art*, London, 372.
8. Lutyens, Edwin, 1 Mar. 1893, letter to JT, TA.
9. Lutyens, Edwin, 3 Sep. 1893, letter to JT, TA.
10. Ridley n. 1], 49.
11. Baker, Herbert, 10 Dec. 1893, letter to Edwin Lutyens, TA.
12. Baker, Herbert, 1934, *Cecil Rhodes, by his Architect*, Oxford UP, Oxford, 37.
13. The first letter from Collie addressed from Groote Schuur is dated 8 May 1895.
14. Susan Beattie mentions in a note in her book *The New Sculpture* that the best group of primary sources for Collie are the letters in the TA: these tell us, disappointingly, very little of Collie's London business, which Beattie was focusing on, but a lot about Collie's work for Rhodes and Tweed's commissions from the same man.
15. Pollock, Alex R., 11 Jun. 1894, letter to JT, TA.
16. Rae-Brown, Colin, 17 Jan. 1895, letter to JT, TA.
17. Tweed, Lendal, 1936, *John Tweed, Sculptor: A Memoir*, Lovat & Dickson, London, 67-8.
18. Herkomer, Hubert, 13 Dec. 1894, letter to JT, TA.
19. Herkomer, Hubert, 18 Jan. 1895, letter to JT, TA.
20. Collie, Arthur Leslie, 2 Jun. 1895, letter to JT, TA.
21. Receipt from Arthur Spencer to JT for £50 for statuette of Robert Burns, TA.
22. Manson, J.B., 18 Jul. 1934, letter to the Misses Tweed, TA.
23. Lutyens, Edwin, 11 July 1894, letter to JT, TA.

24. Lutyens, Edwin, 12 Feb. 1894, letter to JT, TA.
25. Baker, Herbert, 30 Oct. 1895, letter to JT, TA.
26. Collie, Arthur Leslie, 6 Nov. 1895, letter to JT, TA.
27. Pakenham, Thomas, 1991, *The Scramble for Africa*, Abacus, London, 494.
28. Collie, Arthur Leslie, 8 May 1895, letter to JT, TA.
29. Lutyens, Edwin, 29 Mar. 1895, letter to JT, TA.
30. Baker, Herbert, 9 Oct. 1895, letter to JT, TA.
31. White, Robert, 13 Apr. 1895, letter to JT, TA.
32. Tweed, L., [n. 17], 93-7.
33. Ibid., 84.
34. Cecil Rhodes, 1 Apr. 1897, letter to JT, from photocopy in TA, original in the Rhodes Institute, Oxford University.
35. Tweed, L., [n. 17], 88-9.
36. Ibid., 90-9.
37. Baker, Herbert, Jan. 1934, 'Letter to the Editor', *The Times*.
38. Lutyens, Edwin, 30 Sep. 1921, letter to JT, TA.

6: Sculpting the Empire

1. Apart from Queen Victoria, women were hardly ever depicted in public statues until after the First World War.
2. Smith, Tori, 1999. "'A grand work of notable conception": the Victoria Memorial and Imperial London', in Driver, F., & Gilbert. D., (eds), *Imperial Cities: Landscape, Display and Identity*, Manchester UP, Manchester, 23.
3. 29 Jun. 1914, 'Sir T. Brock's Statue of Captain Cook', *The Times*, 5.
4. 31 May 1912, *Whitby Gazette*: article discusses Tweed and Beckett meeting the Urban Planning Committee of Whitby council to decide upon a site for the work.
5. Young, Filson, 2 Nov. 1912, 'The Statue of Captain Cook at Whitby', in *Saturday Review*, 546.
6. May 1913, *Yorkshire Times*.
7. 4 Oct. 1912, *Whitby Gazette*.
8. Beckett, Gervase, 1934, introduction from the catalogue of JT's Memorial Exhibition, 1.
9. Tosh, Josh, 2005, *Manliness and Masculinities in Nineteenth-Century Britain*, Harlow, Pearson, 193.
10. 8 Dec. 1914, *The Age*, Australia.
11. 3 Oct. 1912. *The Yorkshire Post*.
12. 3 Oct. 1912, 'Memorial to Captain Cook: Unveiled by Lord Charles Beresford', in *The Times*.
13. Forwood. William. B., 30 Mar. 1907, 'Lord Clive', in *The Times*, London, 11.
14. Curzon. George Nathaniel, 8 Apr. 1907. 'The Commemoration of Lord Clive', in *The Times*, 6.
15. Landon. Perceval, 31 Jul. 1908, letter to Tweed, TA.
16. May 1909, in *The Saturday Review*.
17. Curzon. George. Nathaniel, 8 Apr. 1907, 6.
18. Corfield, Wilmot, 28 Aug. 1912, *Vanity Fair*.
19. Michalski. Sergiusz, 1991, *Public Monuments : Art in Political Bondage 1870-1997*, Reaktion Books, London, 7

7: War memorials

1. Tweed, Lendal, 1936, *John Tweed, Sculptor: A Memoir*, Lovat & Dickson, London, 168.
2. Sue Malvern in *Modern Art, Britain and the Great War* (Yale UP, 2004) has produced a detailed history of the various schemes run by the Ministry and its predecessor, Wellington House, during the war years showing how the first artists recruited tended to be injured soldiers who had been sent home and then returned to the Front with the task of recording the war artistically.
3. Batterbee, H.F., 23 Dec. 1916, letter to JT, TA.
4. Archer, John, 7 May 1917, copy of letter to General Aylmer Haldane, TA.
5. Yockney, Alfred, 3 Apr. 1918, letter to JT, TA.
6. Yockney, Alfred, 28 Apr. 1918, letter to JT, TA.
7. Malvern [n. 2], 2004, 69.
8. Batterbee, H.F., 10 May 1918, letter to JT, TA
9. Smuts, Jan, 5 Jul. 1918, letter to JT, TA.
10. Smuts, Jan., 10 Aug. 1918, letter to JT, TA.
11. Trenchard Cox, 'Maclagan, Sir Eric Robert Dalrymple (1879–1951)', rev. Anne Pimlott Baker, *Oxford Dictionary of National Biography*, Oxford UP, 2004, [http://www.oxforddnb.com/view/article/34772, accessed 5 Aug. 2011].
12. http://www.1914-1918.net/bat27.htm, accessed 5 Aug. 2011 21: 38.
13. Lane, Ernest Frederick, 22 Oct. 1918, letter to JT, TA.
14. Dating from 1922, now in a private collection, sold at Sotheby's, London, May 1995.
15. This does not mean there are not more of both that were purchased either by Smuts for South Africa or by private art collectors after the war.
16. Lane, Ernest Frederick, 6 Dec. 1918, letter to JT, TA.
17. Lane, Ernest Frederick, 15 Jul. 1919, copy of letter to Herbert Baker, TA.
18. Taffs, J., 12 Jan. 1922, letter to John Tweed, TA.
19. Moriarty, Catherine, 2011, 'The Cenotaph', in *Modern British Sculpture*, Royal Academy of Arts, London, 46
20. King, Alex, 1998, *Memorials of the Great War in Britain: The Symbolism and Politics of Remembrance,* Berg, London, 176.
21. 26 Oct. 1923, RSBS contract between JT and the Memorial Committee of the Rifle Brigade, TA.
22. Verner, Willoughby, 4 Jul. 1919, letter to JT, TA.
23. Archer, Geoff, 2009, *The Glorious Dead: Figurative Sculpture of British First World War Memorials*, Frontier, Norfolk, 41.
24. Ibid., 42.
25. Ibid., 224.

8: Ideal works

1. 23 Oct. 1925, 'British Empire Exhibition', in *Evening News*.
2. Beckett, Gervase, 1934, *Introduction to Catalogue of the Tweed Memorial Exhibition*, London.
3. Tweed, John, 1929, 'Chips from a Sculptor's Studio', typescript of lecture to the Royal Society, TA, 1.
4. Parkes. Kineton, 1921, 136.

Notes

5. JT, n.d., sketchbook, Reading Museum, Reading.
6. For further discussion of Rodin's interest in Michelangelo, see Fergonzi. F., & Buonarroti. C. (eds), 1997, *Rodin and Michelangelo: A Study in Artistic Inspiration*, Philadelphia Museum of Art, Philadelphia.
7. Quoted in Grunfeld, Frederic V., 1987, *Rodin: A Biography*, Hutchinson, London, 181.
8. The location of *Defeat* is currently unknown and *Luigi* is in the collection at Hatfield House.
9. I feel it is possible to date *Luigi* to after this date for two reasons, firstly the work's obvious Renaissance influences and the fact that Tweed in his early ideal works (for which we have definite dates) are always of couples or single females.
10. Tweed, Lendal, 1936, *John Tweed, Sculptor: A Memoir*, Lovat & Dickson, London, 147.
11. Gosse, Edmund, 1887, quoted in Getsy, David, 2004, *Body Doubles: Sculpture in Britain, 1877-1905*, Yale UP, London & New Haven, 124.
12. Tweed, L., [n. 10], 193.
13. 2 Jul. 1920, 'Henley Royal Regatta', in *The Times*, 5.
14. Tweed, L., [n. 10], 192.
15. Ibid., 193.
16. 6 Nov. 1929, *The Standard*.
17. 2 Apr. 1906, 'Review of New Gallery Exhibition', in *The Builder*.
18. Parkes, Kineton, 7 Jun. 1933, 'Review of John Tweed at the Knoedler Galleries', in *Apollo*.
19. Jordan, Michael, 1992, *Encyclopedia of Gods*, Kyle Cathie, London, 168-9.
20. 21 May 1912, 'The Royal Academy', in *The Times*.

9: Conclusion

1. 21 Jan. 1933, in *The Times*, 12.
2. 13 Nov. 1933, in *The Times*, 19.
3. In 1957 the building was demolished to make way for Imperial College and the newly renamed Commonwealth Institute was moved to High Street, Kensington before being closed in 2005 and its collections transferred to the British Empire & Commonwealth Museum.
4. The gift is acknowledged in a letter in TA. The plasters were later moved to the British Empire & Commonwealth Museum in Bristol. After its closure to the public they were placed in storage from where they were stolen in 2007, their whereabouts remain unknown. However, *The Art Newspaper* reported that the plaster had been illegally cast into bronze and then sold at a later date, www.theartnewspaper.com/articles/Rise-and-fall-of-the-British-Empire-Museum/24476 accessed 17 Feb. 2012, 11:23 11 Jul. 1934, 'Some Memories of the late Mr Tweed', in the *Bulwayo Chronicle*, Rhodesia.
5. Jul. 1934, from an unknown newspaper, clipping held in TA.

Index

Bold indicates pages with illustrations

Index